CREATING
Felt Pictures

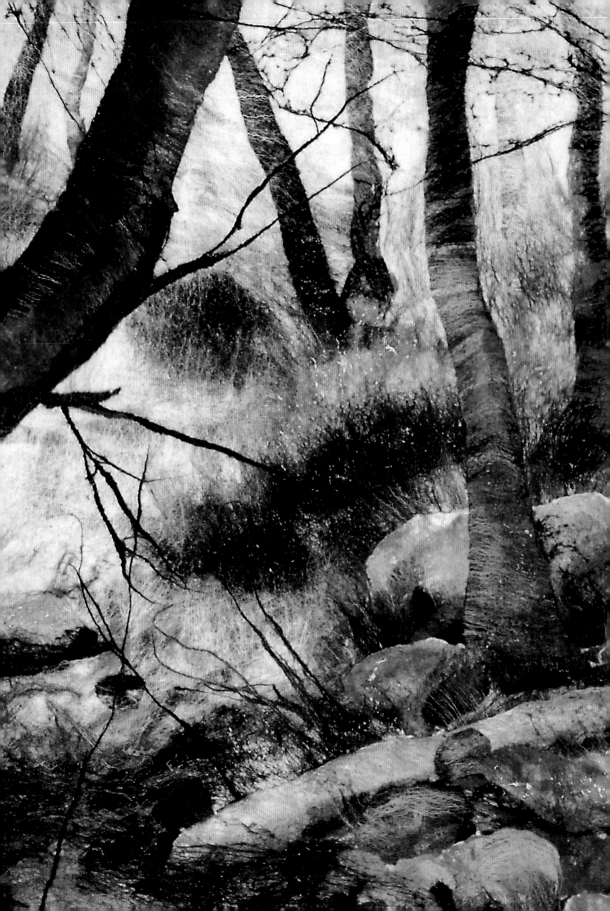

CREATING
Felt Pictures

Andrea Hunter

THE CROWOOD PRESS

First published in 2012 by
The Crowood Press Ltd
Ramsbury, Marlborough
Wiltshire SN8 2HR

www.crowood.com

British Library Cataloguing-in-Publication Data
A catalogue record for this book is available from the British Library.

ISBN 978 1 84797 317 7

Frontispiece: *A Place to Grow* – central panel of a triptych.

Typeset by Kelly-Anne Levey
Printed and bound in India by Replika Press Pvt Ltd.

CONTENTS

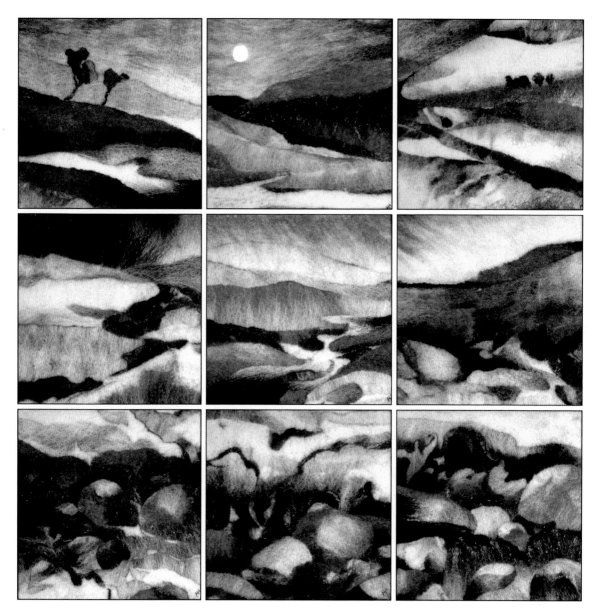

Nature's Cloth, 4 × 4m (13 × 13ft).

INTRODUCTION

My interest in using felt as a medium for pictures grew from my desire to express, artistically, the landscape at my door. I was aware that memories, feelings, experiences and social connections had an important effect on how I viewed my surroundings and thereby had a strong influence on my ideas about sense of place and feelings of belonging. Researching the art of felt making, I was struck by the versatility and other properties of this fabric and also, equally important, I became aware of the impact felt and felt-making has had in contributing to cultural identity across the world.

Felt is the oldest material known to man and pre-dates knitting and weaving. The making of felt can be dated to as far back as 6300BC and ancient writings record how it was used to make clothing, tents, saddles and blankets. The oldest piece of felt known to exist dates to around 700BC and was found in the Siberian Tlai mountains in the tomb of a nomadic horseman. Many people believe that felt was first made by accident when wool was used to protect the feet of travellers whereby the process of movement, pressure and perspiration caused the fibres to compress and create a matted fabric. Felt is fundamental to the nomadic peoples' rich heritage. In countries such as Turkey, Tibet, Mongolia and Russia, it provides for a range of essential needs – tents (yurts) made from sheep's and lambs' wool; carpets for furnishings, prayer and burial mats; bedding for sleeping; clothes and shoes; gifts between families; thread made from camel wool, and rope and ribbons, made from yak and horse hair.

Having some knowledge of felt – its making and use in different cultures worldwide, from ancient times to the present day – stimulated my own ideas about utilizing a medium with which I had some local connection and which has influenced ideas about my own sense of belonging to a distinct community. I found that sheep, both in reality and metaphorically, were central to the shaping of my landscape, community and identity. To try to express my connections, I then began experimenting with making images of sheep in their landscape, utilizing what could be termed as 'hybrid' art, which incorporates a painterly approach to wool to produce a scene and then subjects the 'picture' to the felting process. Thus by drawing from the two influences of painting and felt-making, I can express my own personal affinity with the surrounding landscape, in a way which I like to think echoes that of other societies, in which creativity is linked to the same sort of belonging as mine.

My relationship with the landscape of the Yorkshire Dales stems from my upbringing as a member of a sheep farming family in Wensleydale, where the way of life is closely connected to the day to day activities involved in the breeding and rearing of sheep – lambing, clipping, dipping, fothering, sheltering and hay-making. In the past, farming activities had more of a communal input; for example, farmers worked together to gather in the sheep from the fells for clipping and dipping and helped each other getting in the hay for winter feed, or working together to rescue sheep from under the snow in a winter blizzard. These kinds of activities forged the bonds of community. More local people were farmers, shepherds or agricultural workers, and farmers' wives and children were involved in a supporting role. Mechanization, new

technologies and diversification have brought many changes on the farm and these have impacted on the landscape and community, changing my relationship to both, and introducing new ways of experiencing them.

The women of my past community have been a rich stimulus for my art – their imaginative resourcefulness was a quality much in evidence in their everyday lives. For example, making stobbed or prodded rugs was a communal project and whoever was lucky enough to have a mat in the process of being made, would have a weekly night when several other village women would gather to help, in exchange for refreshments and a catch up on village news. The mats were made with recycled material 'clips' and usually included old woollen garments that had shrunk in the wash and accidentally felted. When the rugs were finished they were much admired, with their unique designs, cacophony of colours and reputation for being extremely hardwearing. Other creative pursuits undertaken were dressmaking, knitting, haberdashery, embroidery and quilting, and were usually undertaken in the evenings. My own mother was competent at making all types of clothing and well into her eighties she was still making mats and embroidered wall-hangings. Whilst these activities had a largely practical use, being creative was also a way of responding to the environment around them and established a pulse in women's lives that was both enriching and sustaining.

I like to think I have an affinity with these women of this bygone age and yet have also assisted in pushing back the boundaries of the ancient craft of felt making. I have been fortunate in practising my art in a time when there is somewhat of a renaissance in the handmade product. This renewed interest has contributed to an increase in small craft industries in rural areas. In the Dales the main economy was traditionally agriculture, but the tourism and craft industries are now making substantial contributions to the rural economy. The success of these small industries has been helped greatly by the Internet creating opportunities in a worldwide market.

Belonging to a place or particular area is getting rarer in our world, especially where more and more people are migrants or displaced, often due to the effects of conflict, global warming, unemployment, or for other economic or social reasons. Over time the displacement of people can result in traditional crafts and techniques been forgotten, therefore, with the world's constantly shifting population, it is very important that we pass on our traditions. Change is inevitable and the development of new ideas is very exciting, but in our enthusiasm to be creative we should always be sympathetic to the traditional skills. Understanding traditional feltmaking, gives the contemporary feltmaker a greater appreciation of the skills involved and in turn can often inspire new ideas. My personal creative journey is ongoing, winding through new ways of seeing and old ways of understanding, giving nourishment to my vision and love of textiles.

OPPOSITE PAGE:
Pennines (detail).

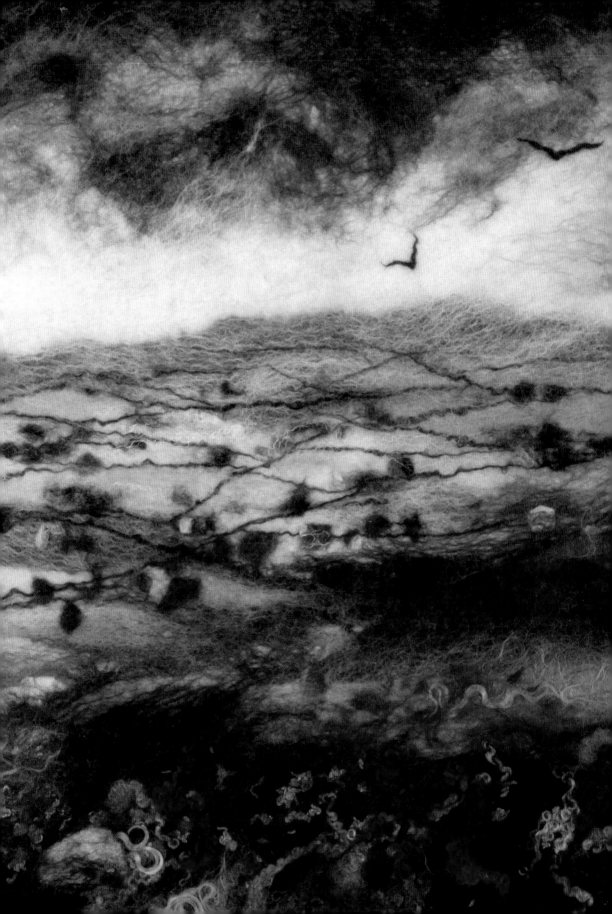

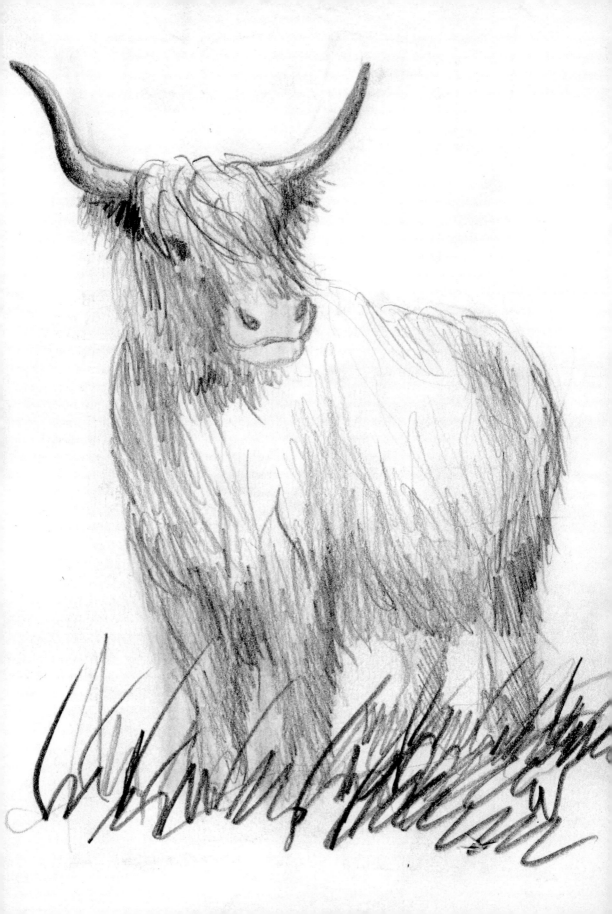

INSPIRATION

Inspiration can be gained from all aspects of life and one's surroundings. Artists, musicians and poets have all been inspired to create, and their work in turn inspires others. Inspiration is very personal to the individual: thus a piece of music that stirs one person may leave another completely cold. Also our preferences change as we get older and experience more of life. Generally the young have a hunger for all that is fast and exciting – they are full of vigour and passion, whereas as you grow older you become more closely connected to the world spiritually. I have a deeper empathy with my surroundings, the world and my place within it now than when I was a student and everything was new and exciting.

I find inspiration not only in other artists' work, but also in the Dales' landscape, its inhabitants and particularly in the dramatic contrasts that the Dales' weather brings. I try to capture a sense of movement in my windswept landscapes by working with fine layers of wool as if it were paint. It is this technique, and a strong illustrative dimension, which makes my work distinctly different from traditional felt artwork, and one which I hope inspires others to experiment with feltmaking – and specifically painting with wool, as this exciting technique may change some people's approach to feltmaking and broaden their views about art and craft.

When looking for inspiration before embarking on a piece of artwork, start by looking at the things you like because you are more likely to be inspired and to realize your best effort if you choose a subject that interests you. Music is a great way to stir your feelings of creativity: listen to some favourite tracks, whether classical or heavy rock – whatever appeals to you or is conducive to the situation. When trying to capture a wild moorland landscape with the wind blowing in heavy rain clouds, I often play very loud rock music because the energy of the music helps me recall the energy of the elements out there on the moor.

Try to connect with your chosen subject: go out and physically experience it – taste it, smell it, feel it, collect all the visual information you can about it in the shape of photographs, magazine cuttings, sketches and the actual object if possible: you can never have too much information. In short, know your subject. Having a good knowledge of your subject is key to a successful interpretation. Much of my work is inspired by the Dales' landscape which surrounds my home, and I am lucky to have inspirational views from my windows – but so often I find myself relying on memories from long ago, as well as perhaps yesterday's walk. My memories hold not only visual images, but also feelings, emotions, smells and the elements, and I draw on all these things to help me put together an image: the smell of the wet peaty ground, the wet fleece of the sheep and the wind on my face, all natural elements of the fells and so much a part of

OPPOSITE PAGE: **Highland cow, pencil sketch.**

Racing Hares
(individual hares 60cm/24in).

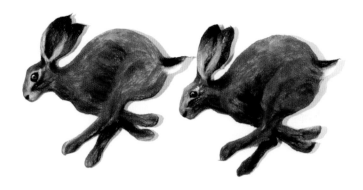

growing up on a hill sheep farm. Sketching also plays an important part in stimulating fresh ideas and perspective in my own work, even though living in the Dales' environment means that I know my subject well.

When searching for inspiration it is very useful to look at other artists' work, to study the medium used, and how they have interpreted the subject. Over the past ten years I have been inspired by several artists. Henry Moore's sculptures and drawings have been a real inspiration to me, in particular his *Sheep Sketchbook*, which is such a joy to peruse: flicking through the pages I smile to myself as I recognize in his drawings many of the poses typical in our own sheep. He captures their solid form so brilliantly, along with their innate character. He obviously spent many hours studying their physical form and observing their individual characters. Studying his sculpture and drawings has helped me to realize a three-dimensional quality in my own work.

On a recent visit to the Yorkshire Sculpture Park I was also impressed by the work of Sophie Ryder, an artist working with wire. Her huge,

free-standing wire sculptures of the Lady-Hare, a hybrid figure combining the hare with human features, form powerful images full of emotion and character. The subtle characteristics of the hare are sympathetically portrayed in the rusty wire with which she works so successfully. Her beautiful wire drawings combine the skill of a drawing with the tactile qualities of sculpture. These works inspired me to develop my own images of hares, creating the figures in isolation and exhibiting them running across the gallery wall. Looking at sculpture and studying the solid three-dimensional forms helps me in forming my pictures because I work with the wool in a very sculptural way, taking into consideration light and shade, employing techniques to give weight and solidity to a form, actually forming the shapes with the wool, adding a little here and taking a little there, thus creating a sense of depth and a three-dimensional quality.

In the feltmaking world the late Jenny Cowen was a great inspiration. I was fortunate to meet her early in my career, and exhibited with her in

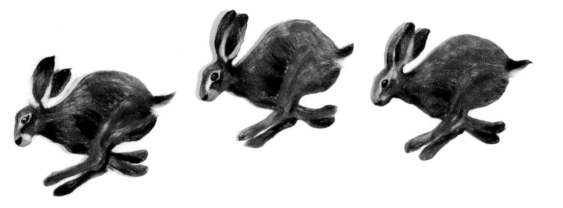

2002. Her subtle use of tone and colour is truly amazing, in particular in her seashore pieces depicting smooth pebbles on a sandy beach amidst the swirling rising tide. Her images are soft and full of depth, and convey a tranquil quality. In observing her work it was clear that she was a true artist working with wool, as her drawing skill was very apparent. This was the first fine art feltwork I had encountered, since everything I had seen up to that point had had a functional element. Jenny's work therefore had a lasting effect on me.

Visiting galleries and exhibitions is a great way to be inspired, as looking at original works can often trigger ideas for one's own work, even when the pieces may seem very obscure and unfamiliar. This is especially useful when you feel the need to refresh your own work or change direction. Never copy the work of others, merely absorb it and let it feed your own creativity.

Collecting visual stimulation is vital to the creative person, and sketching and photography are two of the most effective ways of doing this.

Sketching and Drawing

In these days of the slim, pocket-size digital camera, which can capture an image at the click of a button, it might be argued that the sketchbook is irrelevant – and in one respect this would be right. To simply record a situation or subject, the camera has triumphed over the sketchbook – but the sketch has far greater merits than that of a simple recording tool. The great discipline that sketching demands is observation, and to create a successful sketch you must look repeatedly at the subject. This practice teaches you to really examine a subject, and with practice your hand–eye coordination improves and the whole experience becomes easier and more enjoyable. Carrying a small sketchbook and pencil around in your pocket then becomes a habit, and it becomes an invaluable tool in your creative process.

The watercolorist and the oil painter can both paint outdoors, but for the felt artist working with fine layers of wool this is an impossible pleasure, as the slightest breeze lifts the fibres

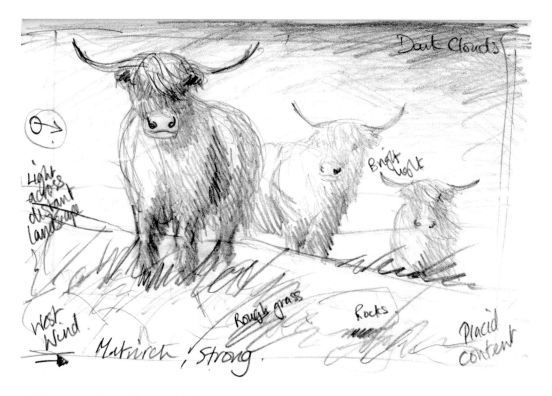

Writing notes alongside your sketch can be very helpful when referring to it at a later date. Here I have noted the light and wind direction, the position of rocks, the type of grass and the demeanour of the cows.

and transports them elsewhere, destroying the felt picture in the process. Therefore as a felt artist, the good outdoor sketch is a very valuable resource once you get back to the tranquillity of the studio. As the sketch is generally used for reference purposes, it is a good idea to write brief notes on it to remind you of any thoughts or ideas which at a later date might be useful when relating it to the felt picture. The quality of the sketchpad is therefore not so important, unless you want to work into the sketch with another medium at a later date, in which case a more suitable, better quality paper is advised.

It is also a good idea to experiment with different drawing materials, as the traditional graphite pencil may not suit you; perhaps set up a still life in the workroom and draw using all kinds of medium, trying as many as you can. This could

prove to be expensive, so why not get together with other like-minded people and share your materials? Well used drawing materials include graphite pencil, watercolour pencil, watercolour sticks, pastel, conté crayon, charcoal, even biro pen – think of all those elaborate biro doodles you have absentmindedly drawn: biro is probably the most familiar drawing medium, so why not use it? Also, you can't rub out biro, which means you will learn to put down only the marks that you really want, and will not be tempted to rub out work which one day might be the basis of a successful design. Alternatively you might choose a combination of drawing materials, and create a mixed media sketch. Basically anything goes; the important thing is just to practise until you feel happy and confident with your chosen drawing material.

For those who are not confident about their drawing skills it is important not to worry too much, because when creating the picture with wool, it will soon be evident that the feltmaker never has complete control over the picture, due to the fact that it has to move around in order for the wool to become felted together. So a perfectly drawn line can sometimes go astray – but this is all part of the charm of creating felt pictures, and should be embraced. The aim in the preliminary sketch is to set out the main objects – often just a series of lightly marked out shapes. Nevertheless it is a good idea to improve your drawing skill by still life practice, as this can often solve any problems that arise when painting landscapes.

First, make sure that the drawing will fit on the paper by lightly marking out the basic shapes: reducing the objects simply to shapes helps you to see the overall picture. All shapes or forms are made from five basic shapes: the cone, the cylinder, the cube, the sphere and the torus, which is a doughnut shape. Combinations of these forms create everything we see.

Whilst looking at the scene and studying the basic shapes it is important to take into account the spaces between each shape, the proportions and how they relate to each other within the space. To do this you need to make some simple measurements. Firstly with an outstretched arm holding a pencil, for example, focus on a prominent object and measure the height, with your thumb on the pencil acting as a sliding gauge. Draw a proportionate line for the size of the paper. Providing your arm is fully stretched at each measurement throughout the whole drawing, this should be an accurate measuring system and ensure that all other lines drawn are in proportion with the first. Next measure the width of the prominent object in the same way. As you progress you will be able to gauge other lines, angles and distances by sight. It is quite a useful exercise to just draw the spaces between objects; this really makes you look hard at the overall scene.

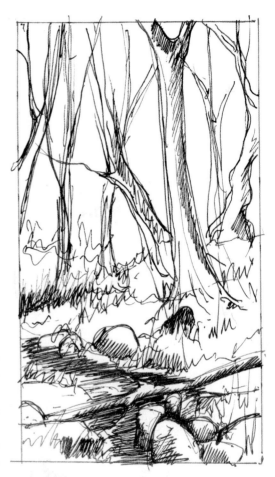

This pen drawing focuses on the strong shapes and contrasts in the woodland scene. This type of sketch is useful when thinking about the composition of a picture.

Plotting spaces between and measuring the size of objects is all part of learning to draw perspective and is an important skill because it gives work a three-dimensional appearance. More precise methods of drawing to scale can be achieved by using a ruler, but this tends to restrict the artist's expression and the results can often take on the appearance of a technical drawing rather than a free-hand sketch. However, the more concentrated methods are useful when scaling up a drawing for a large felt picture. These will be discussed in Chapter 5.

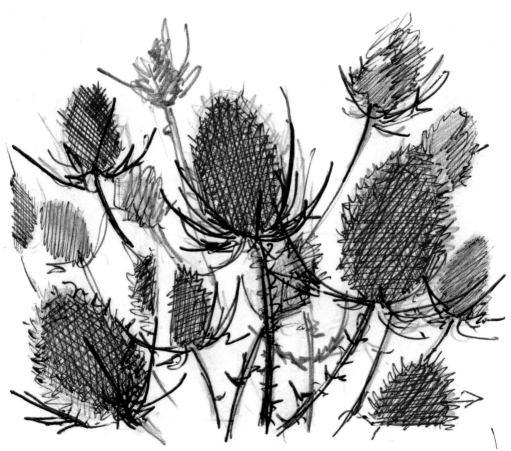

Pencil, blue biro and black drawing pen were all used in this sketch. The biro identifies the shapes of the teasel heads, and the black pen emphasizes the sharp spikes of the stalks.

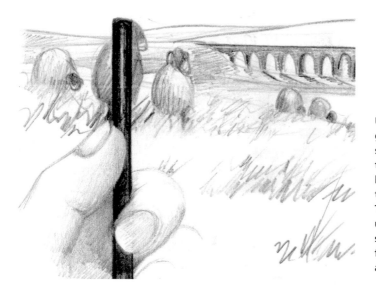

Using your thumb as a sliding gauge is a good way to make simple measurements. Here the height of the sheep is being measured by sliding the thumb down the pencil. This measurement is then used to plot the relative sizes of the other prominent features in the picture, such as the viaduct.

When sketching outdoors, a very simple aid to help you focus on an area of landscape is a viewfinder. In most cases this is merely a piece of cardboard with a rectangular opening cut in it that corresponds roughly to the proportions of your intended picture. A margin of a few centimetres around the opening will suffice to block out any distracting objects, and allows you to concentrate on what you see through the opening. Therefore the viewfinder becomes a simple but effective way of helping you focus on a point of interest. Using two 'L'-shaped pieces of card instead of one fixed rectangle gives the freedom to adjust the proportions of the view; this might be very useful when planning the composition of your picture back at the studio.

The viewfinder isolates a view from the wider surrounding area and helps the artist to focus on the view within the viewfinder.

Photography

The digital camera has opened up a whole new world of possibilities for artists, and good quality shots are perfectly achievable for even the most amateur photographer. For collecting inspiring images to be used in one's work, the digital camera is a huge success and has revolutionized picture-taking. Gone are the days of taking only a few carefully composed photographs because you were mindful of the cost of film. Artists now have the luxury of taking numerous shots of whatever attracts them, in the knowledge that the less satisfactory shots can simply be deleted. The advancement of the LCD screen at the back of the camera has made it easier to frame and view your photographs. In actual fact the whole process of taking photographs has been made considerably more easy by today's compact cameras, which are packed with all kinds of technology to help you get the perfect picture. For the artist, the major features to consider when buying a camera are as follows:

Digital and optical zoom: All digital cameras are fitted with a built-in zoom, allowing you to get closer to your subject. There are two types of zoom, the digital and the optical. The digital zoom electronically enlarges the image, so the object appears closer. This results in some loss of definition. The optical zoom will give you a better result as it uses the lens optics to zoom into the object or scene and captures exactly what the lens is seeing, without reducing clarity.

Megapixels: Digital photographs are made up of millions of tiny dots or megapixels: the bigger the number of megapixels, the more detail in the image. To print standard size photos – 16 × 10cm (6 × 4in) – a three-megapixel camera is adequate; but to print anything larger, a ten or twelve megapixel camera will give better quality results.

Wide-angle lens: For those who paint a lot of landscapes it would be wise to buy a camera with a wide-angle lens. This allows you to fit more in the frame without having to stand a long way back, and is ideal for that panoramic landscape.

When taking photographs, the starting point is usually an object which catches your eye: take a moment to study it within its surroundings,

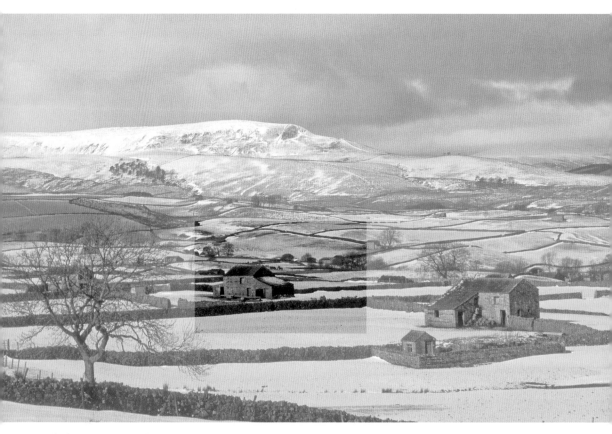

Aʙᴏᴠᴇ: **A view of snowy Wensleydale; the darker area in the picture indicates the area of interest.** (*Courtesy Richard Ross*)

ʟᴇꜰᴛ: **Zooming in on the area of interest, using a camera with a digital zoom. As you see, there is a loss of detail and sharpness in the image.** (*Courtesy Richard Ross*)

ʙᴏᴛᴛᴏᴍ ʟᴇꜰᴛ: **This photograph was taken from the same viewpoint, but this time using a high optical zoom. Although the barn is some distance away, the image has sharpness and clarity.**
(*Courtesy Richard Ross*)

and set about forming the composition, as you would for a sketch. Then use the camera to zoom in and out, taking shots from all different angles. You may surprise yourself and discover an unexpected viewpoint which you would like to expand, such as an unusual object or in the case of a landscape view, a particular group of trees. It is often possible to work up a number of felt pictures from one angle, just by zooming in and out on any given object or landform.

Take lots of pictures so there are several to select from at a later date. It is easy to take a small digital camera when out walking, just to snap that fleeting moment. If, for example, inclement weather is approaching, I will often go out with a view to catching that dramatic shaft of sunlight or the heavy, rain-filled black clouds rolling in. The digital camera makes it possible to do this, and then the pictures can be stored on the computer for future reference.

Another advantage to digital photography is that images can be manipulated with photo-editing software on the computer. Traditionally a painting composition would be worked up from a sketch, with perhaps objects moved a little or even left out all together. Through prac-

tice this usually produces a successful finished piece, but it demands a certain ability to foresee a final result. The modification of a digital image on the computer enables the artist to change aspects of the composition by deleting, crop-ping, cloning, and copy and pasting, resulting in a transformed, yet realistic image. Further manipulation of light, colour and the use of special effects can completely alter the image if desired. Sometimes the results are so impressive that other ideas are inspired, changing not only the composition, but the whole mood and style of a picture.

The down side to working purely from photographs is that you end up becoming too involved with the detail of a picture and lose the essence of what first attracted you to a particular scene or object. I find that part of the joy of working with the wool is its soft tactile quality. Teasing out the wool from the top has a very therapeutic ele-ment to it, and constantly referring to a photo-graph staggers the flow of the movements, thus interfering with my creativity. I prefer to digest all the imagery I have collected and marry it with my thoughts and feelings about the scene, and only refer to photographs if needed.

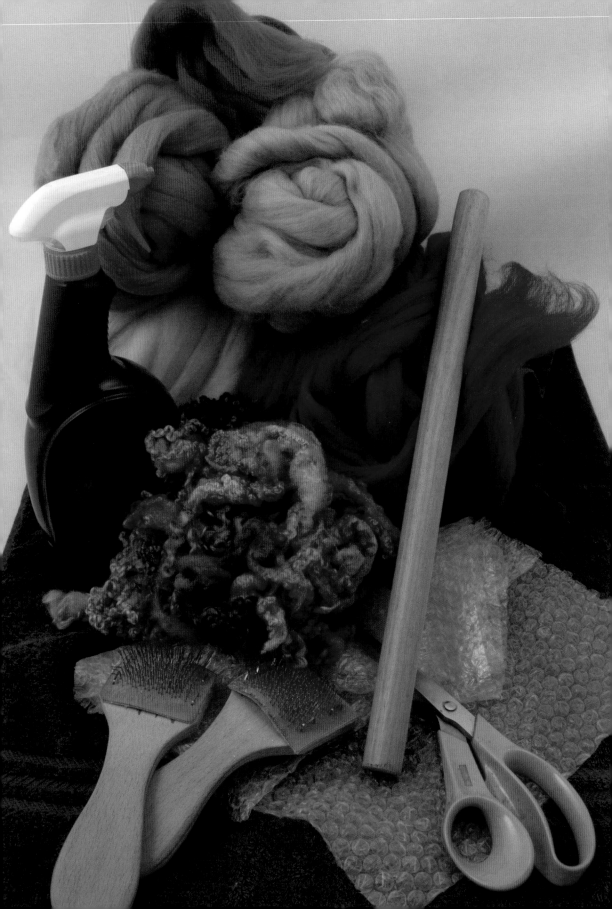

MATERIALS AND EQUIPMENT

The Felting Process

Felt can be made from various animal fibres, but undoubtedly wool is the best. Wool fibre is made up of overlapping scales; these vary in coarseness according to the breed of sheep, therefore some types of wool felt better than others. In order for wool to felt the scales have to open up and entangle with each other when moisture and friction are applied. Only when the fibres have locked together and the shrinking process begun, can the wool be considered felted. This is an irreversible process and one that is both natural and simple. All wool will felt to some degree, but this varies according to the characteristics of each sheep breed. Length and thickness, lustre and crimp are all considerations when choosing the right type of wool, but of all these, thickness of fibre is probably the most important.

The most commonly used system for measuring the thickness is in microns, one micron being equal to one thousandth of one millimetre. A coarse wool would typically be approximately 38 microns, an example of which would be the Swaledale breed. Medium wool would be approximately 30 microns, as found on a Shetland or Blue-faced Leicester, and a fine wool would be approximately 22 microns: a good example of this would be the Merino breed. These measurements are approximate because all the wool qualities vary greatly, depending on the growing conditions and animal husbandry.

The Best Wool for a Picture

Preparing a raw fleece for felting is a long process and one which demands a great deal of patience and knowledge. For this reason it is recommended that the novice feltmaker, in particular, uses commercially prepared wool where all the hard work of washing or scouring and carding is done for you.

Throughout this book there will be frequent reference to 'wool top': this is the name given to wool when it has been washed and carded, and all the short fibres removed. It is then combed and stretched so that all the fibres are running in the same direction in one long, loose, continuous length known as a 'wool top'. This is the favoured choice of the contemporary feltmaker, and certainly the best for creating felt pictures is merino top: its fine fibre is ideal for making the lightweight felt suitable for pictures. The scales on this wool lock together very easily and so it does not demand so much felting, resulting in as much definition as possible being preserved in the images.

OPPOSITE PAGE: **Wools and equpment.**

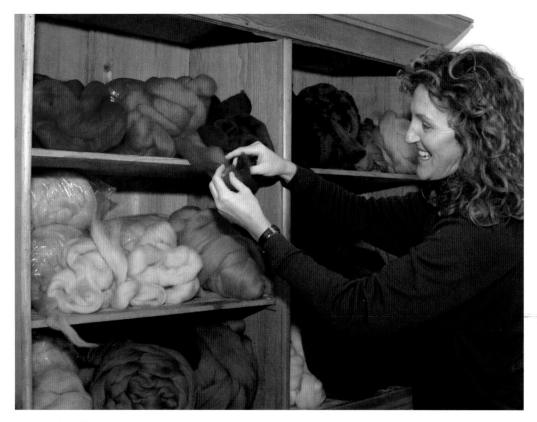

The wool cupboard.

The Merino breed originates from Spain, but the arid conditions of the southern hemisphere countries suit the breed and over the years Australia has become the major grower of merino wool. They are the only nation that breeds sheep purely for their wool, and the quality of the wool produced is arguably the finest in the world. The range in microns is from superfine, 12–13 microns, to coarse, 25–26 microns. The staple length varies from 30–90mm (1–3.5in).

The Merino breed has been successfully crossed with other breeds to improve the wool quality in many countries. This is the case in the Falkland Islands were they have embraced the breed, crossing it with their Corriedale sheep in the east of the islands which has a wetter climate, and the Polwarths in drier areas. The bulk of their wool is in the 27–30 microns category, and the staple length is 80–100mm (3–4in). This wool in certain applications can be considered to be better than the Australian Merino: it has more body and is certainly very good felting wool. Until recently Falkland wool has been sold predominantly to the UK.

Many other types of wool, such as Blue-faced Leicester and to a lesser degree Wensleydale, will felt quite well, but their real value as far as the felt artist is concerned, is in their usefulness in adding surface texture to a work. This is discussed, along with other materials, in Chapter 6.

The felt artist's studio.

The Feltmaking Workplace

The workplace should have plenty of light and preferably a source of water. A major consideration is that the work surface is at a height that will not strain your back, as you may be working at it for some time. The surface should be durable, or protected from any water spillage by a plastic sheet. Working in the same position for long periods is not good practice, so be sure to have regular breaks. Why not listen to some music as you work – this encourages you to move around and not to stay rigidly in the same position, and it can also help to inspire creativity.

Ideally the feltmaker has a dedicated workroom with an adjustable, angled table, storage, and plenty of space for those bigger projects. But if this is not possible, the kitchen is usually adequate.

Equipment

One of the great things about feltmaking is that the equipment needed is simple and inexpensive; there is no need to go out and buy costly tools to be creative with this medium, and very often the necessary items are already to hand in your kitchen or garage. The essential items are:

- Old towel: dark-coloured towel is recommended
- Roller: a length of wooden dowel or a broom handle
- Bubblewrap, with small bubbles
- Plant spray, or any clean, redundant spray bottle
- 2 lengths of Velcro, approximately 20cm (8in) long, both hooked and fuzzy strips

SOAP SOLUTION

A mild alkaline solution helps fibres become more elastic and encourages them to open and lock together to form felt. The best alkaline solution for the feltmaker to use is some kind of soap: this breaks down the natural oils, of which there are still traces even in commercially processed wool. Any kind of soap can be used – soap flakes, natural soap, shampoo for greasy hair, or washing-up liquid, although the latter can create a lot of bubbles, the air from which will be caught between the fibres, preventing them from locking together, and so the felting process will take longer. When using shampoo or washing-up liquid, one good squeeze in a pint of hot water is sufficient. My preferred option is the use of soap flakes.

Make the soap solution as follows:

Put 4 dessertspoons of soap flakes in a 600ml (1 pint) jug.

Add 600ml (1 pint) boiling water; stir until the flakes have dissolved.

Leave to cool completely.

Stir and pour into a plastic container or glass jar for storage. The solution should resemble a semi-transparent slime.

When needed, pour one part soap solution in spray bottle with four parts warm water, and shake vigorously.

The solution is now ready for use.

- 2 large elastic bands (if you do not have Velcro)
- Soap solution (*see* panel)
- Wool tops
- Small carders (optional)
- Photographs or sketches for reference use (optional)

Useful Tips and Information

Bubblewrap is best used when making the fine felt suitable for pictures. Some feltmakers use a piece of net to lie on top of their work to aid felting, but special care is needed in this technique to ensure that the wool fibres do not become entangled with the net, resulting in fine detail being destroyed when the net is removed. The same problem arises if a bamboo mat is used in direct contact with the front of the picture. Bubblewrap (with small bubbles), however, is a good friend of the contemporary feltmaker, its merits in this capacity being as follows:

- The texture of the bubbles helps to create lots of friction in the felting process. The air in the bubbles warms up as the piece is rolled, and thus it generates its own heat. This warmth speeds up the felting process.

- Mess in the work space is reduced since only a little soapy water is needed, and this is contained within the bubblewrap (unless excessive water has been used). Less water around means a less chaotic work area, making feltmaking a more attractive project for schoolchildren to experience.

- The bubblewrap can be used for feltmaking several times over, or until the bubbles pop.

Small carders are less cumbersome than full size carders.

• Bubblewrap is often a throwaway product, and its use as a recycled material is one way of helping the environment.

It is an advantage to place a dark-coloured towel under the bubblewrap, because then the first layers of white wool can be seen clearly, and the evenness of the layers easily judged. The towel can then be removed, but kept at hand to mop up any water seepage.

As an alternative to a wood roller you can use a length of pipe insulation; these are available in various widths, and can be bought from DIY stores and plumber supplies.

The Velcro strips should be of both hooked and fuzzy type, and these two parts need to be fixed together at an appropriate length so they will wrap round and secure the ends of the rolled-up felt.

For a picture 30 × 50cm (12 × 20in) you will need approximately 50g (1.75oz) white wool tops and 50g coloured tops of your choice. This should be more than adequate, and there will usually be some wool left over.

A pair of small carders is quite useful to blend coloured fibres together, but they are not a necessity.

ESSENTIAL FELTMAKING SKILLS

Making the Picture Base

It is essential that the first layers of wool are laid down correctly, as these are going to form the base of the picture. It is useful to think of the first two layers, usually of white wool, as the paper or canvas. The aim is to tease out the wool in very thin, even layers, as instructed in the following guide. Concentrate on getting each layer nice and even, and avoid pulling out thick lumps of wool, which will result in a thick, uneven felt. Likewise beware of areas where the wool is too thin, as this can work into holes in the felting process. Take your time, as it is worth getting this stage right. Think of it as a foundation: get it right, and you are then free to be as innovative as you like in the creative stage.

Before starting to lay down the wool, consider the size of the picture and remember to allow for the shrinkage that occurs when wool is turned into felt. Different wools have varied shrinkages, but with merino, which is the preferred wool for picture-making, it is advisable to allow an approximate shrinkage of one third. However this is only a guide, and a lot depends on the desired end result: thus an unglazed wall hanging may need to be a harder, more robust felt, in which case the piece will need to be rolled more, and in turn the shrinkage will be greater. On the other hand, to create a detailed illustrative piece that is to be glazed and framed, you will not need to roll so much and the average shrinkage may be 20 per cent of the original area.

Step-By-Step Guide to Creating a Felt Picture

1 Lay the towel down on the work surface.

2 Lay the bubblewrap on top of the towel, bubble side up.

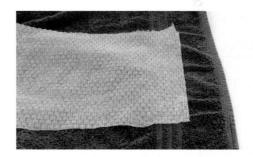

A dark-coloured towel underneath the bubblewrap will allow you to see clearly the evenness of the first layers of white wool.

3 Take the white wool top and hold it gently in one hand, approximately 10–15cm (4–6in) from the end, and with the other hand, grip the tip of the wool between your bent first finger and thumb. Gently pull the wool from

the top; it will pull out in approximately an 8cm (3in) length.

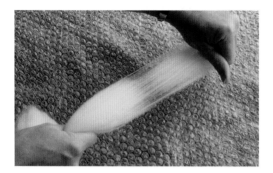

Gently pulling the wool from the top.

4 If you have difficulty doing this you are probably gripping the wool too tightly and holding it too close to the end. Be relaxed and enjoy the beautiful tactile quality of the wool.

5 Lay the pulled wool down on the bubblewrap in a vertical direction, and work across in a nice, even row. Do not work right up to the edge of the bubblewrap, but leave a space of at least 10cm (4in) all round.

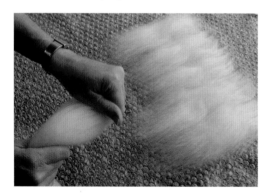

Laying out the first layer of wool.

6 The second and all consecutive rows should overlap on to the previous row by approximately 4cm (1.5in), or half of the length; this ensures an even layer. Continue until the desired area has been covered.

7 The second layer is also usually white, but it depends on the picture. If, for instance, the sky is very dark and dense, it would be best to use a dark colour or black wool in the appropriate area, because whatever is put down in these first two layers will have an effect on the finished felt. It can be an advantage to use two layers of white wool as the white has no dye on it and therefore usually felts better, helping to make a good strong base.

8 The second layer of wool is handled in the same gentle way, but this time the wool is laid down on top of the first layer at right angles, creating what is sometimes referred to as a 'warp and weft' effect. The wool should overlap on to the previous row, as in the first layer.

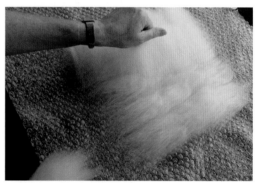

The second layer is placed at right angles to the first.

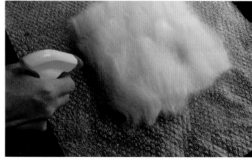

Spray the two layers of wool with the soapy water solution before starting the creative stage.

9 Make sure the whole first layer is covered, then spray the layers of wool with some of the soapy water solution, just enough to damp the whole area.

10 There is now a good base on which to work, and the fun can really start. In this, the third layer, the fibres are randomly placed according to whatever is being created. Different artistic skills applied to wool and other fibres are discussed in the following chapters. However, always be mindful of the importance of making sure that the third layer completely covers the whole area: even if white is wanted in the picture, do not rely completely on the first two layers, or this could result in a thin area.

11 It may help to spray a little soap solution on the picture as work progresses to gain more control over the fibres, but take care not to saturate it. This is the creative stage of the picture, and it may take anything from a couple of hours to several days.

12 If the work is to be left overnight or for a day, cover it lightly with bubblewrap to

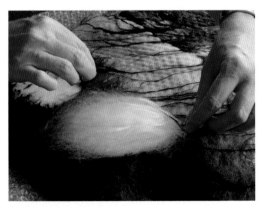

Creating a felt picture involves using a range of techniques along with the use of various fibres. This photograph, for example, illustrates mulberry silk being incorporated into the picture as part of the creative process.

prevent it from drying out. If it is to be left for several days, leave it uncovered to prevent it from going smelly.

13 When the picture is finished, it is useful to take some time away from it before starting to felt it. Ideally just cover it and leave it overnight; on coming back to it the next day you will see it with fresh eyes, and can sometimes notice glaring mistakes or things you don't like. Don't be afraid to change things, because once the picture is felted very little can be changed.

14 When you are completely happy with the picture the felting process can be started.

15 Spray the picture with the soapy water solution and place a piece of bubblewrap on the picture, bubble side down. Take care not to spray too much water on the work or it will become saturated and the fibres will have difficulty locking together because they are slopping around in too much liquid; the work should be just damp.

16 Before starting to felt the piece by rolling it, a useful tip is to apply a little pressure and stroke the hands over the bubblewrap in an outward motion from the centre. Spend approximately ten to fifteen minutes doing this. The fibres will start to lock together, so when the rolling starts, any movement in the image will be kept to a minimum.

17 Carefully lift up the bubblewrap and check that the picture is still how you want it. At this crucial point only make minor adjustments, as the fibres really do not like being disturbed once they have started to lock together: if the picture is disturbed at this stage the fibres may refuse to felt together.

18 Replace the bubblewrap as before, and position the wooden dowelling at one end of the work. Roll up the picture quite tightly round the wood roller, taking care not to get creases in the felt. Secure each end with Velcro tape and roll quite gently backwards and forwards approximately fifty times.

19 Unroll the picture and gently stretch out any creases that may have formed, then roll up as before, but this time from the opposite side: this will help to ease out any creases that are developing. Roll again fifty times, and apply more pressure. The rolling is quite physically demanding, if it is done correctly. Make sure you roll from the finger tips to the wrist with firm pressure, and move the hands in and out along the roller to make the felting even.

20 When the felt is unrolled it will be apparent that it is shrinking more in the direction you have been rolling. To bring the piece back into the original shape, turn it 90 degrees and roll it one hundred times. Increasing the speed of the rolling will build up more friction and hasten the felting process.

21 Repeat this step of turning and rolling as many times as is necessary until the desired shape, size and effect is achieved – but remember the picture needs to be sufficiently felted for it to be judged

Rolling the felt picture.

fit for purpose. Don't worry about any indentations left by the bubblewrap, as these will disappear.

22 To test that the wool has felted, try to pick up a few fibres between finger and thumb: if fully felted the fibres will not separate from the surface. Another method of testing is to take the edge of the picture and rub it between the fingers and thumb; there should be no movement between the layers. If the picture is not sufficiently felted then repeat the rolling.

23 When the felting process is finished, all the soap must be removed from the picture by rinsing repeatedly in cold water until it runs completely clear. A mild solution of vinegar and water as a final rinse to remove every last trace of soap is optional.

24 Squeeze out all the excess water and either hang out the work in the open air, or drip dry it over the bath. When almost dry, press with an iron, or with a steam press on a wool setting.

Pre-Felt

Pre-felt, as the name suggests, is made up of layers of fibre that have been felted just enough to make them hold together, but not enough to be locked together and classed as fully felted. These pieces of partially made felt are referred to as 'pre-felt' pieces in the following chapters, and are very useful in creating definition in the picture. Shapes cut from the pre-felt stay crisp when incorporated into the body of an unfelted picture. The initial felting inhibits the fibres from merging with the unfelted ones, the shapes are clearly defined and when used with softer lines and forms, a great depth can be achieved in the work.

RIGHT: **This picture illustrates the use of pre-felt pieces to create the clean lines of the tree trunks, this helps to create the illusion of depth in the picture.**

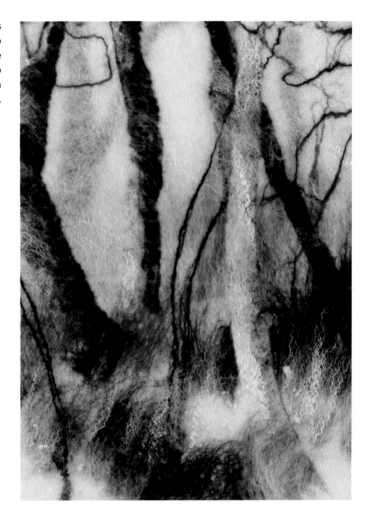

Care should be taken when rolling pre-felt, because if it is rolled too much the fibres will become too felted together, thus preventing the body of the picture from locking into them.

Making Pre-Felt

1 Lay out two layers of wool (in the desired colour) on to bubblewrap, as instructed in the step-by-step guide.

2 Spray with soapy water solution and place more bubblewrap on top, bubble side down. Roll up around the roller and roll for approximately 100 times, then stop, check, and turn 90 degrees, as instructed in the guide. Roll for a further 200 to 300 times, or until the fibres are locking together but not fully felted.

3 The pre-felt is now ready to be incorporated into a picture. Cut out the desired shapes and lay them on to the picture. Any surplus pieces can be rinsed in clean water and dried, ready for use in a future project. If you require a more dense pre-felt, use three layers of wool and roll slightly longer.

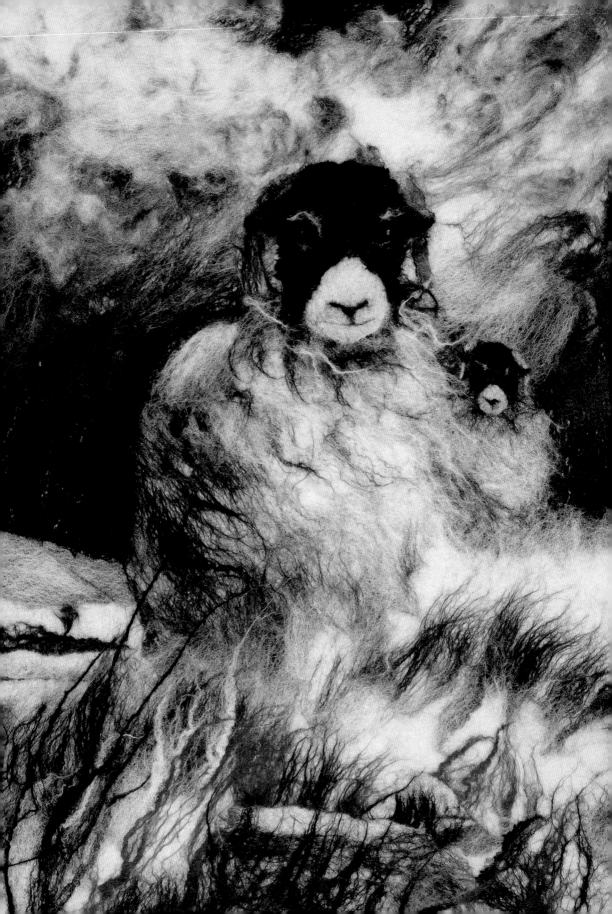

DRAWING WITH WOOL

If you love drawing and have a passion for fibres and specifically wool, drawing with wool is definitely for you. Many of the principles that apply to a graphite drawing can equally be applied to drawing with wool: composition, perspective, balance and tone are all to be considered just as they would in a pencil or charcoal drawing. A drawing can be as simple or as in depth as you want it to be, and the only limitation in drawing with wool is in the fineness of detail, as very small marks made with the wool can disappear in the felting process; but there are other methods of adding very fine detail which are discussed in this

OPPOSITE PAGE: *Swaledale*, 70 × 95cm (19 × 37in).

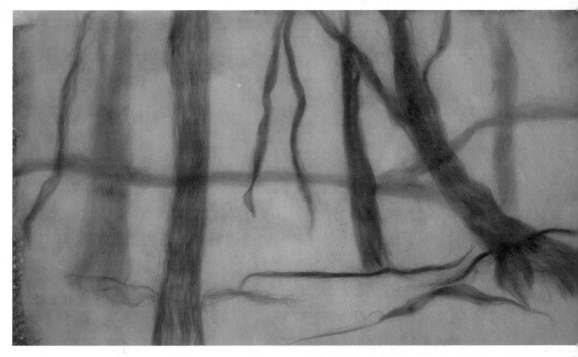

Hardraw Beck. This simple wool line drawing plots the positions of the trees in the landscape and acts as a framework on which to build the picture. The colours are strong enough to be clearly seen, yet will blend into the picture when more detail is added. Adding colour and detail to this picture is illustrated in Chapter 5.

chapter. The term 'drawing with wool' is used here because at this point your drawing medium is simply wool, and only after the felting process has been completed does it become felt.

Once the two base layers of wool have been laid down the basic design can be planned out. Initially it is a good idea to have a sketch or photograph to work from, but be careful not to get too involved with details at this stage. A simple line drawing with wool is sufficient to plot the positions of the basic shapes. Choose wool colour that will blend in with the subject matter – usually a medium or light tone, so the marks can be seen clearly, without them being too obtrusive as the picture progresses. Choose something like a light grey for a mono-chrome piece, and a light brown or green, for instance, on a coloured landscape. Whatever is chosen, it must be in harmony with the colour range intended for the picture. Never use black as this is simply too harsh, and there are often dire consequences when the picture is later felted, as the black wool emerges through lighter shades of wool.

As you progress into the picture and more detail is added, be mindful of the fact that the drawing will become softer as a result of the felt-ing process, so don't be too reserved with those gentle lines or they may completely disappear in the finished piece. There is quite a lot to think about, but look upon these first attempts as experimental works, and above all enjoy work-ing with this beautiful medium.

A simple wool line drawing can be developed into the chosen area of interest: for instance, it may be used as the decorative design for a bag or an article of soft furnishing. It can be worked into as a detailed monochrome drawing, or built up into a full colour picture. The following chap-ters deal with all aspects of creating a successful felt picture, from the initial planning stage to the presentation of the finished work.

Types of Line

Most of the planning out of a picture can be done using a soft line of wool, just as, for instance, a gentle mark would be used in a charcoal draw-ing. Start by gently holding the wool top in one hand, and with the other, pinch a piece of wool from the end of the top using the first finger and thumb, and gently pull. Before the wool pulls out completely from the top, release it and take another pinch of wool along its length, and repeat this as many times as is needed to make one continuous length of wool.

This may be difficult at first, but try to roll the pulled-out wool between your first finger and thumb as you pinch it out. For those with a rea-sonable level of manual dexterity this action will improve with practice, and it creates a stronger, more consistent length of wool, which starts to resemble a crude length of yarn. In fact this action echoes a form of hand spinning, albeit at its most basic level. The result is a length of wool of uneven width that can vary between approximately 2–10mm ($1/8$–$1/3$in), depending on the size of your fingers and the pinch of wool taken.

This length of wool can then be manipulated to create a vast range of lines and marks useful throughout the whole project; the most utilized of the range are described and illustrated in the following pages.

Short, thin lines can be difficult to achieve as they tend to shuffle around and can become displaced in the felting process. It is therefore a good idea to leave such details until the finished picture has been felted and dried. These small marks can then be added by way of a felting needle to secure the detail into the felt. Longer lines have more surface area and so the results are usually better.

From one simply teased out length of wool many different lines and marks can be made; these form the basis of drawing with wool, and behave as a 'freehand line'. As a result of the

RIGHT: Wide hard line. To achieve a thick, heavy line, take larger pinches of wool at shorter intervals. When you have the desired length of line, a light spray of soapy water solution will help you control the wool. This line is useful in portraying a strong, heavier shape or line, perhaps in the foreground of a picture or, as in this example, the dark silhouettes of the trees.

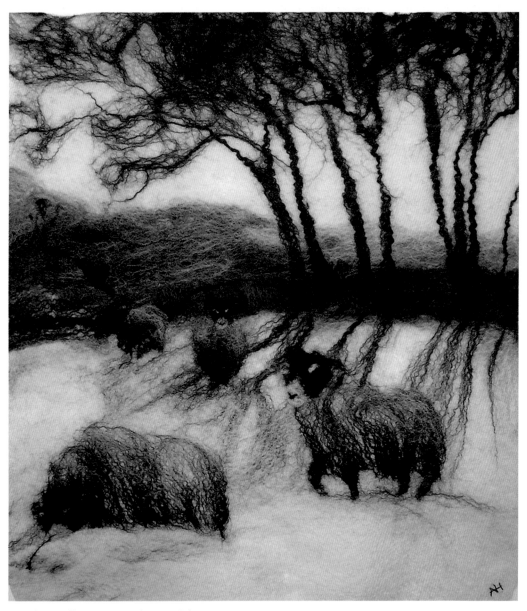

Evening Walk, 70 × 80cm (19 × 31in).

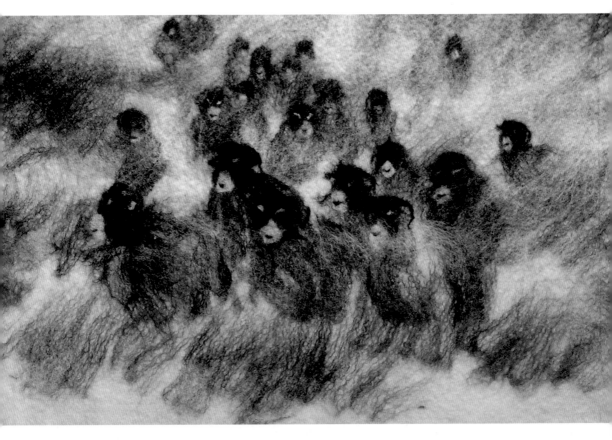

Out of the Mist, 80 × 55cm (31 × 22in).

Wide soft line. This can be achieved by taking thinner, less dense pinches of wool from the top so there is more space between the fibres, resulting in a wider yet softer line. This type of line has multiple uses, but is valuable in working up a basic sketch line in areas were a shadow may fall or, as in this example, where it has been used to portray the bodies of the sheep.

felting process this freehand line can appear much softer when the picture is finished, and this softness is usually considered a very appealing aspect of a felt picture. However, there are occasions when the image demands more definition – for example, when creating a more three-dimensional effect – and this can be achieved by the use of pre-felt pieces.

RIGHT: Thin hard line. To achieve a harder line, take smaller pinches of wool, then spray the whole length with soapy water solution and nip together or roll between fingers and thumb. To achieve a very thin line, take even smaller pinches of wool and stretch them out almost to breaking point. This line is useful to outline an object or to emphasize a particular landform within a landscape. The hard line is used effectively in this example to illustrate the bent trunk and twisted branches of the hawthorn tree silhouetted against the winter sky.

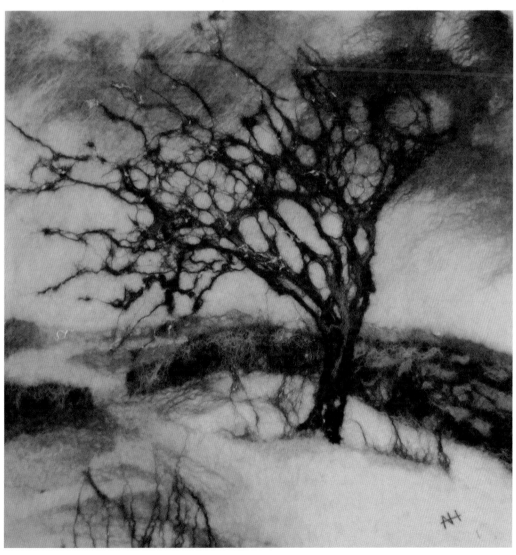

Winter Hawthorn, 60 × 60cm (24 × 24in).

Thin wispy lines are achieved by pulling a very fine gossamer-like layer of wool from the top. This is very useful for depicting distant hills in a landscape, or features such as the soft, wispy mane of the Dales pony as shown here.

BELOW: *Chocolate*, 60 × 75cm (24 × 29.5in).

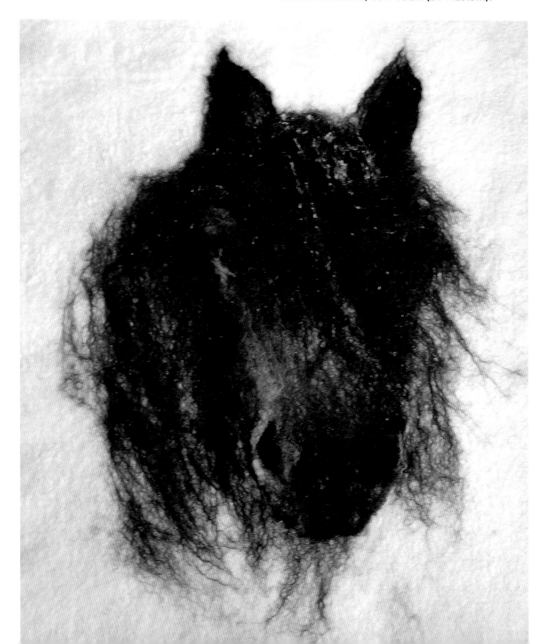

Pre-Felt and Its Use

Drawing with different strengths of line will help to create depth in your work, but in some cases the physical changes which occur due to the felting process demand that more definition is applied in order to create a convincing result. Clearly defined shapes can often appear more solid and distinct to the viewer, and a successful technique to achieve this effect is in the use of pre-felt pieces. When shapes are cut from pre-felt, the cut edges retain their sharpness even when incorporated into the felt picture, and this makes their use very beneficial in creating a three-dimensional illusion. Pre-felt is therefore a very valuable material to the felt artist, as it can be incorporated into a picture at any stage in the creative process, to give that extra definition that really makes a subject stand out. It is especially useful in portraying a focal point in the picture (*see* Composition later in this chapter).

Great consideration should be given to the wool used to make the pre-felt. The colours and tones used must be appropriate to the picture; it is therefore beneficial to think about this at the composition stage. Think about where in the picture the pre-felt might be used to achieve the best effect, then consider the colours associated and any textural effects that might complement the pre-felt feature. I usually spend quite a lot of time making the pre-felt specifically for one picture. For example, making one large piece 80 × 60cm (31 × 24in) will incorporate many colours and tones that might be suitable for use in the picture. Even if the pre-felt is not used, the spare pieces are often useful for other projects. Never throw anything away, as a spare scrap may be helpful to give a crucial highlight in a subsequent picture.

Whilst it is possible to follow certain techniques (as mentioned above) to create three-dimensional effects, it is of greater importance to master the skill of perspective drawing, which can greatly enhance the life-like quality of the picture. The sketch stage is usually the

The pre-felt has been made particularly for this picture. Shapes are cut from the pre-felt, with careful consideration as to their eventual placement.

The pre-felt pieces are placed in the picture.

The dark wool in the areas of sky where the cotton grass heads will be placed is cut away to prevent it from felting with the white wool heads, as this would result in the white appearing dull. This would be very undesirable, as the main focus of the picture is the soft glossy tops of the cotton grass.

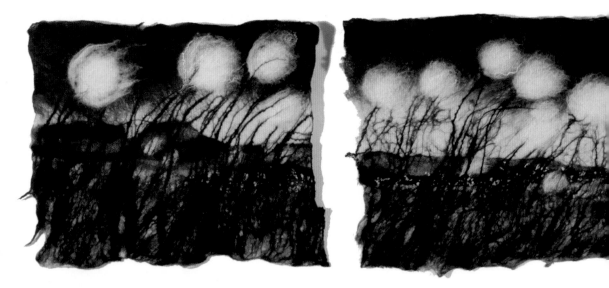

Amidst the Cotton Grass, triptych 110 × 60cm (43 × 24in). In the finished picture the viewer is under the illusion that they are amidst the cotton grass and looking through and beyond to the distant hills.

point at which perspective is thought about, particularly when out sketching a landscape where your ideas inevitably have to be transferred to the felt picture back in the studio. Often adjustments in scale are made, and the composition and perspective reassessed. If you are planning the composition straight on to the wool, the same rules of perspective apply, but your drawing will be with wool using a freehand line.

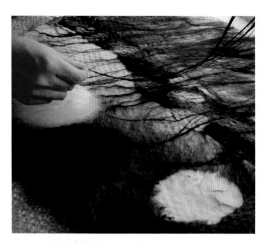

The long, thin lines of dark wool are added to portray the slender stalks of the cotton grass in the foreground.

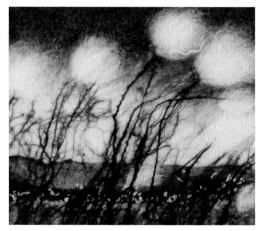

A detailed view of the finished cotton grass reveals the textures of the wool, the silk in the heads, and the cotton nepps used to suggest cotton grass in the distance.

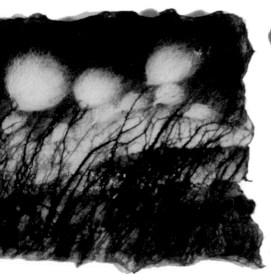

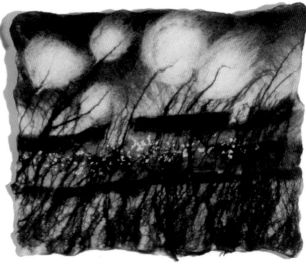

Perspective

Observe a line of trees or a row of houses: each will appear to get smaller the further away from the viewer they are, until they finally meet with the horizon – this is known as the vanishing point. Establishing the horizon or eye level is fundamental to a competent drawing. Most artists do not feel the need to create technical drawings to portray perspective successfully, but instead tend to rely on a good understanding of eye level and vanishing points in order to create a correct but more natural-looking drawing effectively.

First you need to ascertain an eye level. Your eye level is established as though you were looking directly ahead regardless of where your main object or subjects are situated in the scene. Stare straight ahead from your viewpoint at the horizon – this is your eye level, and will be represented by a horizontal line across your work. The point on the horizon directly in front of you is the vanishing point, at which all parallel lines converge. The vanishing point

gives objects an impression of depth. When all objects vanish to one common point this is known as 'one point perspective'.

A good way to practise perspective drawing is to draw simple boxes in one point perspective. When you move on to drawing more complicated objects, these can then be broken down into simpler, more familiar shapes, and the application of perspective is made easier; for example, a building may be simplified into a rectangle with a triangle on top to represent the roof.

To really make a work come alive, two point perspective must be used. It is a little more complicated than one point perspective as there will be two vanishing points, but it is a much more useful drawing system and is more widely used by artists, as objects drawn in two point perspective generally have a more natural look as the sides of the object vanish to one of two vanishing points on the horizon. Where several objects are seen at various angles there will still be one eye level, but numerous vanishing points to create the different angles. Where an object appears above the eye-level line, the

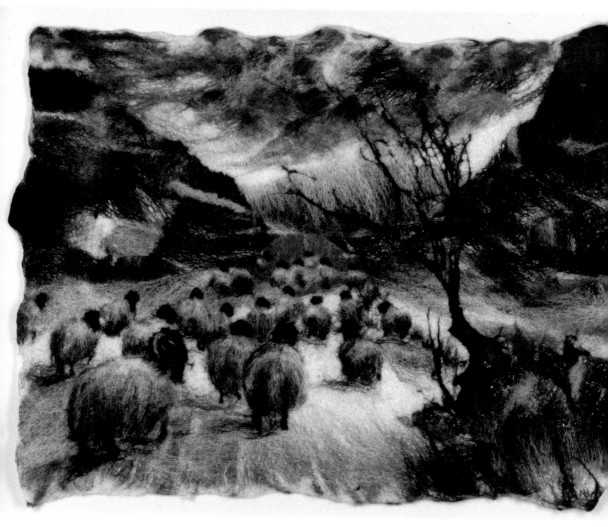

Down from the Fell, 80 × 95cm (31 × 37in). **This picture illustrates one point perspective, as all the sheep and the land forms seem to converge to one point on the horizon between the dips in the hills.**

front vertical line will be drawn above the line and all horizontal lines will slope down to the vanishing point. Objects below the eye level will appear as though we are looking down on them, and the vertical lines will remain vertical and the horizontal lines will slope up to the vanishing point.

By altering the proximity of the vanishing point to the object, you can make the object look bigger or smaller. The closer you are to an object, the closer in to the sides the vanishing points will be, and the angles of the shape will be more acute. The further away you are from a subject the further out the vanishing points will be. Remember vanishing points will always be on the horizon, and the horizon will always be on the eye level of the viewer. Becoming aware of space and the relative size of objects in relation to the viewer's horizon is key to drawing perspective successfully.

Here the structure of the ram has been reduced to basic shapes to illustrate how all objects can be simplified to make perspective drawing a little easier.

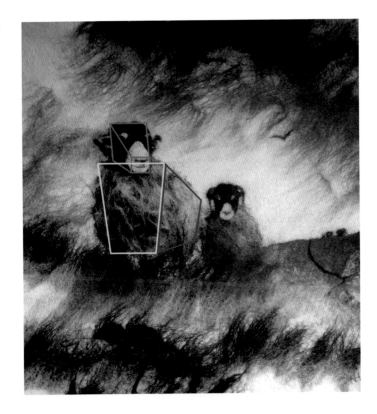

Most of the building in this diagram is above eye level, therefore the known horizontals such as the ridge and the edge of the roof will slope down to eye level.

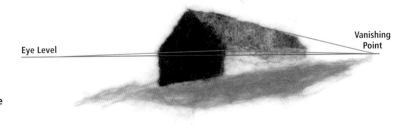

Eye Level

Vanishing Point

Eye Level

Vanishing points are off the felt

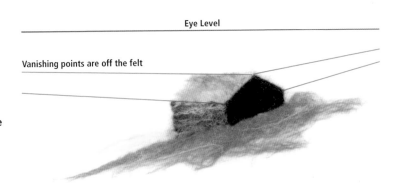

Most of the building in this diagram is below eye level, and therefore the ridge and the edge of the roof will both slope upwards to eye level.

Composition

Composition is the arrangement and combination of objects and shapes within the borders of a drawing. The aim is to bring the gaze of the viewer towards the centre of interest in a well balanced, aesthetically pleasing composition. There are no hard and fast rules regarding composition, only guidelines, due to the fact that there may be many ways to successfully arrange a particular group of objects in a picture, as each artist's personal preferences influence their choices. However, it is a good idea to become familiar with the basic guidelines and to try out various arrangements in a sketchbook, as a badly composed picture can ruin even the most skilfully executed drawing or painting. Thus it is worth spending time on planning a picture.

Proportions

When you plan a drawing, first think about the subject: will the arrangement take on a predominantly horizontal layout, in which case it may be wise to choose a landscape format, or will it suit a vertical layout, in which case a portrait format might accommodate it best.

Consider the size of the picture: traditionally the general thought is that the bigger the picture, the more detail it will need to make the space interesting. However, many abstract minimalist works would prove that concept to be erroneous, since their success is often determined by the artist's skill in balancing a composition.

The rule of thirds is a method of arranging a picture into harmonious proportions by simply dividing the whole picture into three equal parts

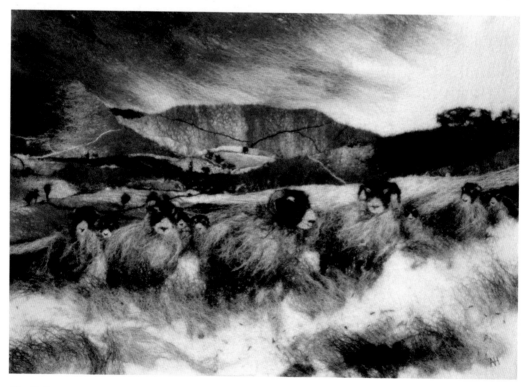

The Dales, 100 × 80cm (31 × 39in). This picture illustrates the use of the rule of thirds. The sheep are in the foreground, which makes up the bottom third, the hills beyond are in the middle third, and the sky makes up the top third.

each way. These lines can be drawn in as a temporary guide, or just a mental image made of them; this helps to prevent the picture being visually divided in half, something which is easily done when drawing landscapes. The horizontal thirds make it easier to create areas of distance, middle distance and foreground, when viewed from the top down. These areas can be completely disregarded if the focal point of the picture demands a less conventional approach.

The Focal Point

The focal point is the primary centre of interest in a drawing, and the area where the artist wants the viewer to focus most of their attention. When choosing a focal point, think about what you want the picture to say, and the focal point should help to express the idea. It does not have to be an object: it could be a beautiful sky, or even a highly textured area in the design.

On the Run, 60 × 70cm (24 × 27in). **The ram is the focal point of the picture, but because he is slightly off centre the eye is led from him to the other sheep and the hills beyond. Thus the viewer is successfully led into the picture.**

Once it has been chosen, the rest of the scene can be assembled round it using a number of artistic devices and techniques to highlight it.

Always place the focal point off centre, unless there is a particular artistic reason not to do so. Placing an object dead centre commands the viewer's full attention, and any other important features may be ignored. By positioning the primary focal point off centre the viewer will firstly focus on that, but will then intuitively register the other, secondary focal points, which are usu-

ally important elements of the composition. This does not have to be another object, it could be a distant landscape or sky.

If the focus of the picture is an animal or bird in profile pose, always give it breathing room by placing it looking into the frame with space in front of its face.

Secondary focal points should be positioned close to the primary focal point to help guide the viewer's eye to the centre of interest. This is a very powerful device, if for instance it is coupled

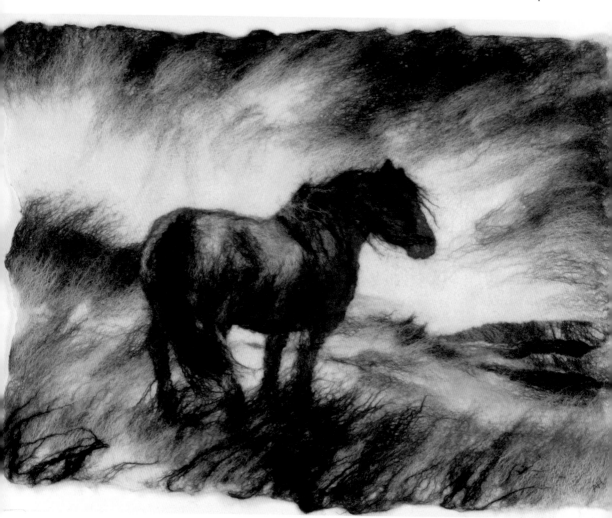

Back to the Wind, 90 × 80cm (35 × 31in). **The focal point is clearly the Fell pony, and the distant fells are the secondary focal point. The pony is positioned looking into the picture and to the fells beyond; this gives him plenty of breathing space and an air of contentment.**

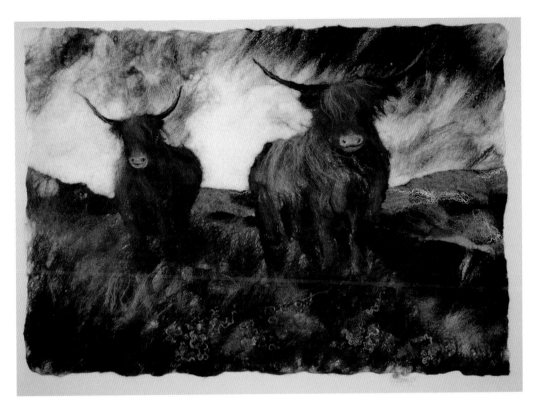

Stroppy Lass, 110 × 85cm (43 × 33in). **The primary focal point in this picture is the young Highland cow in the foreground. The cow standing slightly behind the focal point looks as if she has a more docile character. This, coupled with her position in the picture, gives more prominence to the focal point.**

with a directional element, such as the turn of a figure's head in the direction of the primary focal point.

Directional lead-in features are very useful in a composition, as they direct the viewer to the focal point. Actual lines or implied lines can navigate the viewer and can take any form, providing it works with the subject matter. In a representational drawing, lead-in lines are usually implied lines rather than actual: a typical lead-in might be a stream, a flight of steps or a wall. When properly executed the eye follows these lines directly into and through the picture. The natural direction for a viewer to enter the picture is the bottom left-hand corner; this is therefore a good location to place a lead-in

line. Placing lead-in lines on the right-hand side of the picture may take the viewer's eye out of it, and the biggest error would be to put a leading line exactly in the corner, as it forms the shape of a arrow head and points the viewer directly out of the picture.

Three-Dimensional Illusion

Overlapping objects, or placing them in front of others, helps to generate a sense of depth, as a strong three-dimensional illusion is thus created. To overlap subjects, simply draw some objects in front of others, so they appear closer to the viewer. However, careful consideration should be given to the spacing of these objects, to avoid an overcrowded composition.

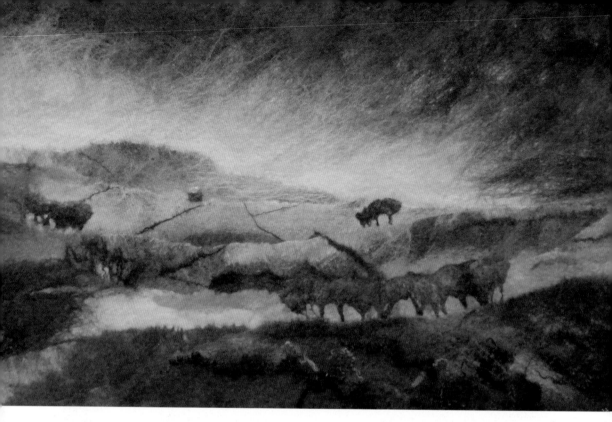

Autumn Colour, 90 × 80cm (35 × 31in). The rich, deep colours used in the foreground give weight to the picture, encouraging the viewer to enter into it. From this point the viewer is directed into the picture by several implied lines in the form of walls leading into the distance.

Objects in the foreground that are drawn with more detail and definition will be enhanced, and the use of pre-felt in this situation can greatly increase the three-dimensional effect. Overlapping can also unify a drawing, and helps to create a pleasing composition.

Balance

Carefully planning the balance of objects in the composition often determines the overall success of the picture, as a well balanced drawing is more aesthetically pleasing. To determine a good balance it is important to take into account the size, placement and values of the subjects in the picture. The basic principle is similar to that of a seesaw, in that if the subjects are the same size and are the same distance from the central point then they will balance. If a small object at one side is to balance a larger object on the other

side, it will have to be a greater distance away from the centre point, or alternatively a second object must be added to give more weight.

As well as the placement of objects, the grouping of objects is very important to the balance of a picture. If objects are grouped in even numbers of two and four the composition is less artistically pleasing, because even groupings tend to look rather stiff and regimental. It is more interesting to place objects in groups of odd numbers.

Masses of light and dark values can also affect the balance of a picture, and these areas need to be identified and planned into the composition in much the same way as objects. Placing all the dark objects on one side and the light ones on the other side of the picture can result in an unbalanced composition. Moving things around a little, or making them slightly lighter or darker than they actually are, can sometimes make a huge difference to the balance of a picture. Dark colours generally add weight to a picture and

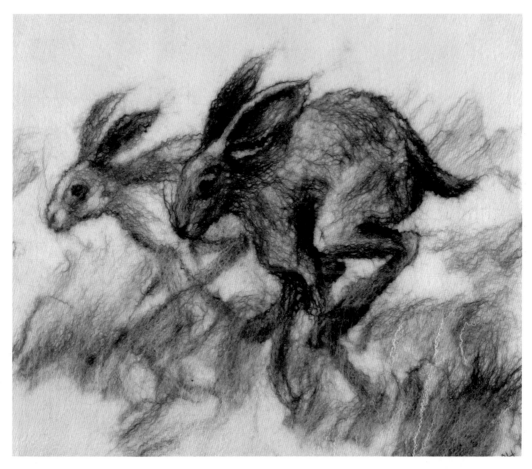

The Race, 85 × 70cm (33 × 27in). By overlapping the two hares and drawing the one in the foreground in more detail, the illusion of depth is created.

lighter colours add space. The artist often makes numerous small sketches to help them create a good composition, and in addition to this – or instead of it – some artists digitally modify images on the computer: they can change as little or as much of the composition as they desire with the click of a button, and they can then quickly judge with more certainty whether or not the composition works.

The skill of planning a composition can take time to develop, but the more preparatory design that is done, the easier it will become; this in turn makes collecting subject material easier, and the whole process becomes more instinctive.

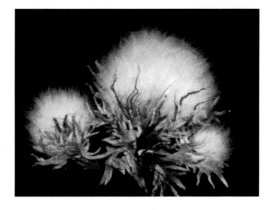

Cluster of Heads, 95 × 80cm (37 × 31in). The three thistle heads make a well balanced composition.

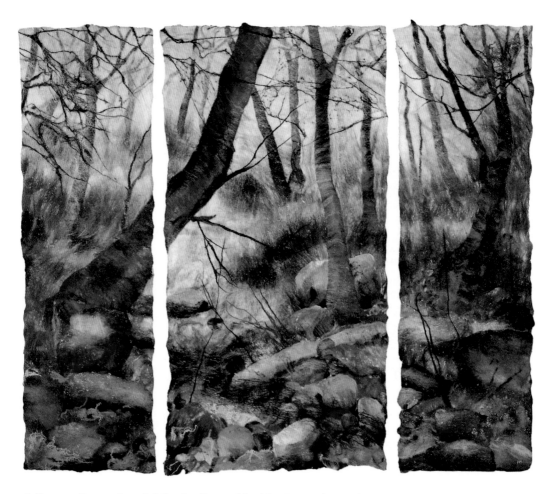

A Place to Grow, **triptych 2.5 × 2m (8 × 6.5ft). This picture shows the use of a full tonal range, from the light tones of the morning sky to the mid tones of the undergrowth and the darkest tones in the tree trunks. All have been carefully considered to create a balanced composition.**

Large-Scale Felt Pictures

Large-scale felt works should only be embarked upon by those with a very good understanding of feltmaking, or by those doing a group project with an experienced feltmaker – in which case it can be great fun and very satisfying.

The composition of the picture should be worked out on paper, and then visually transferred on to the wool. This can be quite daunting at first, particularly if the felt picture is to be considerably larger than the sketch. But

with practice, a methodical approach and the aid of simple grid lines, the exercise can be successful.

A series of horizontal and vertical lines are drawn over the paper design in a grid formation of, for example, 2cm (¾in)squares. A grid of the same proportion but with larger squares, 20cm (8in) for example, is drawn with string or yarn, on to the base layers of the felt picture. These are the kinds of proportion that might be used when making a very large picture or wall hanging. The image can then be studied and

mentally transferred square by square in order to maintain the composition and proportions of the design accurately.

This is the only effective method of scaling up a design on to a large felt picture. The grid lines are removed when the design is transferred and before the detailed creative work begins.

Laying out the base layers of wool for a large wall hanging can be time-consuming and tricky, as the artist may well have to work on the floor To make life a little easier in these circumstances it is a good idea to use a piece of lightweight, white, needle-punched felt to act as the first two layers. In the industry this product is referred to as 'non woven' and is produced by carding fibres into a thick web known as a batt. This is then pressed under a machine incorporating a needleboard with thousands of felting needles. As these needles are repeatedly raised and lowered through the web, the fibres become interlocked. The resulting material has numerous applications in feltmaking, and provides the felt artist with a good base on which to work.

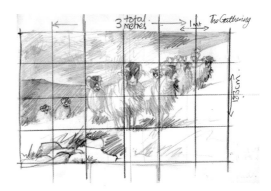

Grid lines over this sketch helped to scale up the image into a large triptych.

BELOW: *The Gathering*, 3 × 2m (10 × 6.5ft). This felt triptych was scaled up from the above sketch. The transfer of the individual characters is not exact, but the proportions are very close, and that is the most important element of scaling up to a large picture.

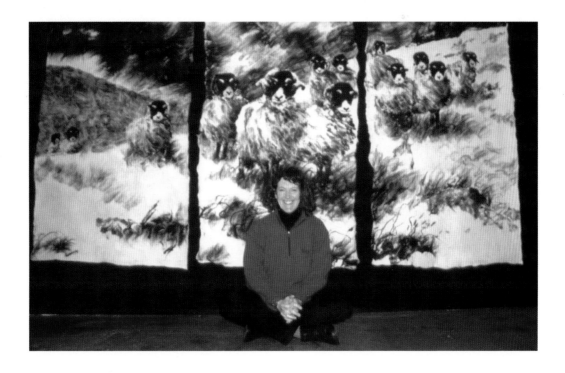

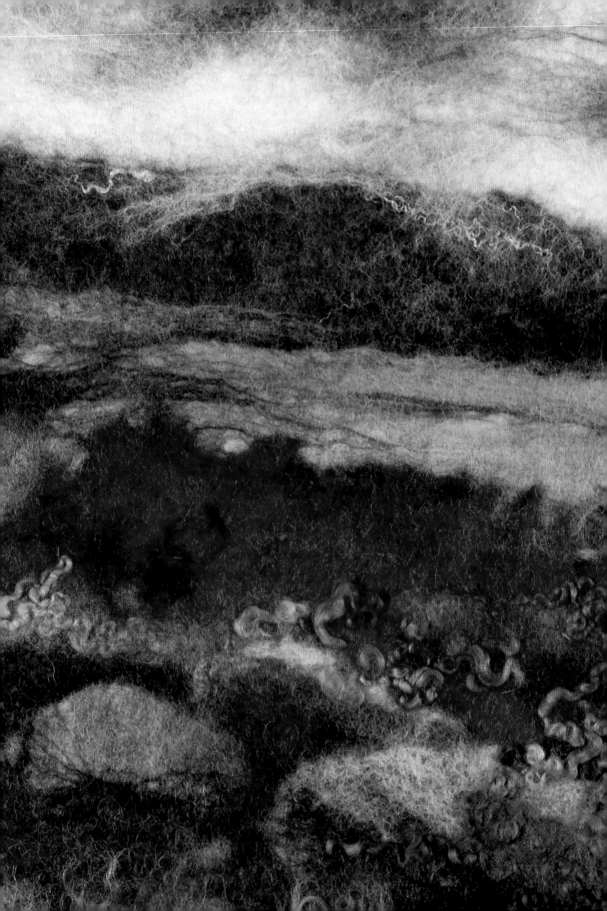

PAINTING WITH WOOL

This chapter will look at colour and how colours are blended, primarily through the mixing of synthetic dyed wool tops, to create a broad spectrum of colour in a felt picture. Natural dyeing and the use of natural dyed tops as an alternative will also be explored. How to use colour, and the methods of mixing colour, will be particularly discussed, as will the importance of light and shadow to create form in a picture. Many of the principles of painting can be applied to felt picture-making, which is why I like to refer to this method of creating as 'painting with wool'; it most accurately describes what I do, although to the general public unfamiliar with feltmaking this might give an impression of someone who works with wool yarn.

Just as the felting process affects the definition of a design, it also affects the colours used. It therefore has a fundamental effect on your work, and should always be a consideration throughout the course of the creative process. Different coloured fibres will affect each other as they felt together. In a controlled manner this can work to the artist's advantage, but when layering a variety of colours, thoughtlessness can result in unwanted colours appearing when the picture is felted. A good understanding of the basic colour wheel is an advantage for mixing colours, but our individual perception of colour is also influenced by background surroundings and light variations. And of course the very nature of wool means the absorption of colour is very different to paint.

Artists' paints generally have colour names which incorporate the common pigment name, such as 'cobalt blue' or 'cadmium red' or a standard pigment identification code, making it easy for artists to familiarize themselves with each colour; this also means that instructions are easier to follow. Suppliers of wool tops have their own individual colour charts, bearing marketing names which often only give a poetic suggestion of the colour. The felt artist must then decipher which colours to order. Most good suppliers offer a colour sample pack, for which there is usually a charge, but for those intending to do a lot of feltmaking it is worth the cost.

Through a process of careful consideration and experimentation it is possible to build up a good knowledge of the colours and how they blend together. However, with the growing popularity of feltmaking there are now very good ranges of synthetically dyed wool tops widely available, so you may not feel the need to do much colour mixing yourself. But for those aspiring to create works using the skills of a painter, mixing your own colours is vital to give a three-dimensional quality to a picture. It is a good idea to study the painting of great artists and note how they create light and atmosphere through colour, as well as depth and form through considered colour mixing.

When a supplier of wool tops offers a varied repeatable range of colours, it may be useful to make a colour wheel using the tops. This will take a little time, but it should prove to be a valuable guide in the future. The colour wheel shows the primary, secondary, tertiary,

OPPOSITE PAGE: *High Places* (detail).

warm, cool and complementary colours as used in colour theory, regardless of the media used; the colours are as follows:

• The three primary colours are red, yellow and blue. The fundamental rule of these three colours is that they cannot be made by mixing other colours together.

BELOW: **Felt colour wheel created from the three primary colours of red, yellow and blue, using commercially dyed merino wool tops.**

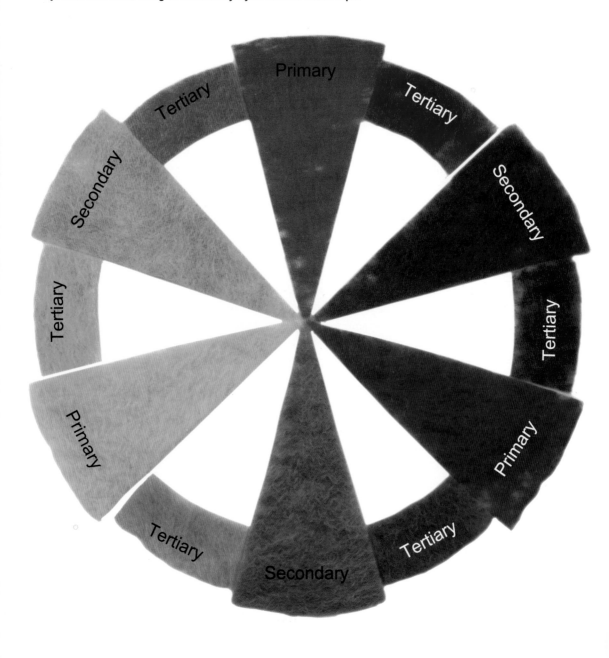

- The secondary colours are orange, green and purple or violet. These colours are created by mixing equal proportions of any two of the primary colours, and they appear directly in between the primary colours on the colour wheel.

- Tertiary colours are created by mixing a primary colour with its adjacent secondary colour. For example, if red is mixed with orange the tertiary colour will be a red-orange colour.

- Warm colours are red, orange and yellow.

- Cool colours are green, blue and blue-violet.

- Complementary colours are directly opposite each other on the colour wheel. For example, red and green are opposite each other, as are red-orange and blue-green, making them each other's complements. When complementary colours are next to each other they intensify each other. When they are mixed together they neutralize each other, producing a greyish colour, sometimes with a bias towards one colour, depending on the colour proportions.

Browns and greys contain all three primary colours, as does black, but black is not generally considered to be a colour, as it absorbs all colours and reflects none back. The result of mixing different colours to create black is known as a chromatic black. A common way of creating this black is to mix a dark blue with an earthy yellow and a touch of red. However, it doesn't really matter which colours are used to make a chromatic black, as long as you like it and can remember how to repeat it. Obviously the darker the colours you start with, the darker the result. Alternatively you could just use the manufactured black if it suits your needs.

Mixing Colours

Coloured wool fibres can be mixed together in much the same way as a painter mixes colours, but when mixing coloured wool the felt artist has a number of different blending techniques at their disposal, each creating its own interesting effects. Each separate fibre will retain its own commercially dyed colour even when blended with other fibres; thus the blend will comprise all the individual colours used.

Hand Blending

Hand blending is probably the most commonly used method of mixing coloured tops, because it is the simplest and does not involve any tools. Select the colours, then pull short lengths of wool from each top, making a mental note of the proportions of each colour in order to maintain a general consistency. Tease the colours together with your hands by repeatedly pulling the fibres apart then placing them back together, until you are satisfied with the blend. This method gives a good mix, but when closely observed the colour and texture of the individual fibres are still visible in the finished picture. Undeniably this is one of the appealing qualities of a felt picture.

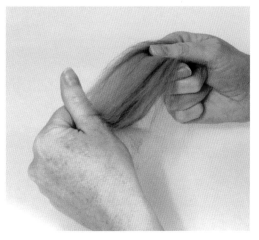

Hand-blending Merino wool tops.

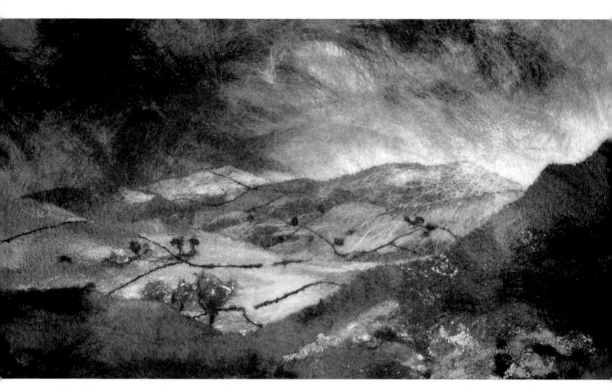

Mid Summer Storm, 80 × 55cm (31 × 22in). The sky in this picture illustrates the effects of hand-blending wool: the texture of the wool fibre and the individual colours used are quite visible, and this effect creates a quite painterly abstract sky.

Carding Merino wool tops.

Carding

Carding has long been used as a process to straighten wool in preparation for hand spinning. Carders are wooden tools used in pairs, each with a face covered with closely set fine wires to catch the fibres. For the purposes of mixing small amounts of coloured wool, much smaller carders are recommended, as they are less cumbersome and there tends to be less wool wasted. A good alternative to carders are dog-grooming brushes which can be used in the same way.

To mix coloured wool together, the selected wool tops are placed on the wire face of the left-hand carder, and the wire face of the right-hand carder is drawn across it. This is repeated until

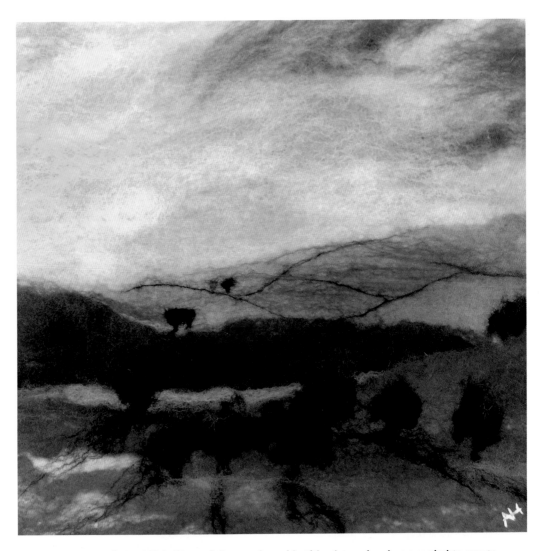

Sunset, 40 × 40cm (16 × 16in). Most of the wool used in this picture has been carded to create smoothly blended colours; this adds to the overall soft, tranquil atmosphere of the picture.

the colours are blended together sufficiently. This method produces a smoother blend of colour, and the results in the finished picture can be very soft depending on how long the wool has been carded. This method of blending is very effective in depicting skies or water.

Overlaying

By laying one fine layer of coloured wool over the top of another, such as yellow over red, the secondary colour of orange is created. The repeated cross-fibre overlaying of wool can result in a dense block of colour being achieved. This can be a useful mixing technique when making pre-felt, in order to create a strong area of colour.

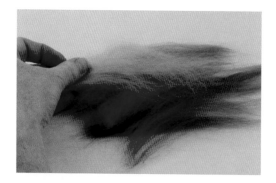

Overlaying merino wool tops.

A more fluid approach is to allow thin layers of different coloured wool to randomly overlap to create various tones. The latter technique has similarities with the thin washes of paint so often used as a technique in watercolour painting.

Also the white wool used to make the first layers of the felt picture has a profound effect on the conveyance of light in a picture. For example, when very fine layers of pale yellow and green wool are used to portray a sun-drenched landscape, it is the white wool that will provide the brilliance of the light. This is also apparent in watercolour painting,

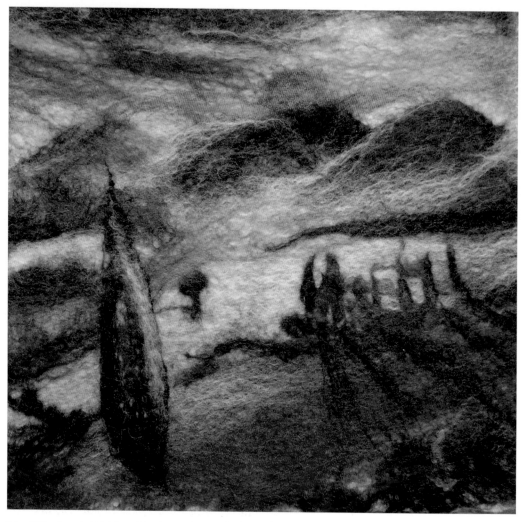

The Hills Around Urbino, 50 × 50cm (20 × 20in). Several different-coloured wools have been layered over each other to create a foreground rich in colours and tones.

when the artist relies on the paper to provide the light. White wool in the base layers will make the colours in subsequent layers slightly lighter, and this should always be a consideration.

The degree of light can be varied by adjusting the thickness of the layers of wool, although if a dense dark colour is required it is advisable to replace the white background with a darker colour. The technique of using wool as if it were paint demands quite a free-flowing use of the fibres, and these can sometimes unintentionally become overlapped in the felting process. Thus a variety of shades and hues can reveal themselves – and some feel that this is yet another appealing quality of the felt picture and should be embraced.

Pointillism

This technique was first developed by the Impressionist artist Georges Seurat, who became well known for his novel technique of painting in tiny dots of colour. For our purposes the dots of paint are replaced by dots of wool or pre-felted wool. The first option involves tiny bits of wool snipped from a thin length of top and creates a very soft, mottled effect, useful, for example, in portraying a leafy tree far in the distance. In the latter option, the dots cut from pre-felt maintain more definition and the colours stay as individual dots, yet they appear to merge optically.

When making the pre-felt, follow the guidance in Chapter 4, then chop the pre-felt into pieces of approximately 5mm (¼in); smaller than this and the pieces risk disappearing in the felting process, or the effect being too indistinct. These dots then lock into the background when felted. A varied application creates a subtle change of colours and tones, especially if the pre-felt was made from two or more colours. In preparing the area to be worked on, it is a good idea to follow the method that Seurat himself used, by putting down a broad background of colours, then building up the area with multi-coloured dots.

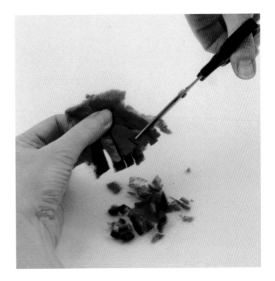

Snipping pre-felted wool into small pieces, to be incorporated into a picture. The pre-felt is made from several shades of the same coloured wool, resulting in a subtle gradation of tone in the finished picture.

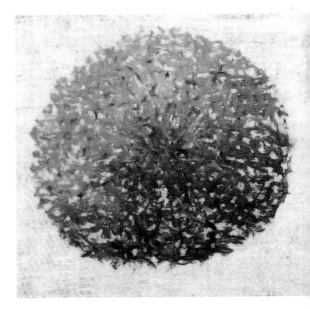

Pink allium. The nature of the allium flower, with its mass of compacted little flowers, lends itself to the technique of pointillism. The shape of the flower is successfully formed by the careful gradation of tone within the small dots of pre-felt.

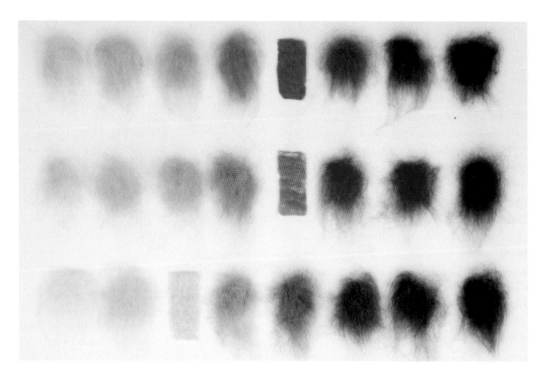

Colour values are enhanced by blending different proportions of white or black wool to commercially dyed red, yellow and blue wool tops. A range of tints and shades are achieved from the three colours.

When complementary colours of equal value are placed together, they each appear more intense and will stand out in a picture.

Colour Values and Creating Form

The value or tone of a colour is the lightness and darkness of that colour, and for every colour a value scale can be created. To help understand the value scale of colours, let's first consider the values from black to white. This value scale is often referred to as the 'grey scale', where black is at one end of the scale and white at the other, and contrast is the relationship between the two. Thus the further apart the values are on the scale, the greater their contrast, and the closer they are on the value scale, the less their contrast. Objects appear further away when they have a low contrast, and the gradual increase of contrast makes them appear closer. Objects in a bright light have a high contrast, and objects in a diffused light – such as a cast shadow or in the distance – will have low contrast.

The same rules can be applied to the value scale of all colours, and it is by applying these values that we are able to create form.

When observing a coloured object you are in fact seeing many values of any one colour: these are often referred to as 'tones'. It is important to recognize each colour's values, because form is created by first simplifying a colour into three values: light, middle and dark. The middle value is usually the closest to the actual colour of the object. The dark value (shade), perhaps the shadowed area of the object, is usually the middle value colour with its complementary colour or black added. The light value (tint) is the middle value colour, usually with white added. However, in the case of felt picture-making, if working with thin layers of wool, it is possible to create light by applying the wool very thinly and relying on the white wool in the background layers to provide the lightest value of the colour. Shiny objects will also have a highlight. When these three values are blended, many values of that colour are created, and so the full form or shape is revealed.

The value of colours should not be confused with the intensity of colour. Although similar, the intensity of colour means its brightness or dullness. A pure colour is a high intensity colour, while a colour mixed with its complement is a low intensity colour; this has a visually neutralizing effect on the colour and it appears dull.

The intensity of colour influences the impression of distance in a picture; thus dull, low intensity colours will always appear further away, and intense colours will always appear in the foreground. Two high intensity complements placed side by side will appear to 'zing' and stand out in the picture.

Light and Shadow

A picture can appear flat and uninteresting until bright lights and shadows are introduced. When painting light effects the dark tones of the shadow must be considered, because without them the light areas will not stand out. The darker the shadows are, the lighter the light will appear and the

greater the contrast. When very dark areas are adjacent to very light areas there will be maximum contrast and a greater visual impact.

A good way to study light and shadow is to set up a still life indoors, using angle-poise lamps to create strong directional light; this can be really helpful in understanding the relationship between light and shadow. The best time to study light in the landscape is at sunrise or sunset, when the sun is low in the sky. The light effects can be beautiful, and with long, cast shadows the landscape can appear quite mystifying.

There are three basic types of shadow. The first is the shadow side of an object, the second is a cast shadow which is absent of light caused by an object, and the third is a proximity shadow that occurs when objects touch or nearly touch. All

The light is shining on the stone from the left, creating a shadow on the right side of the stone. This picture also illustrates a cast shadow falling to the right.

Proximity shadows can be seen between the stones and where the stones sit on the surface.

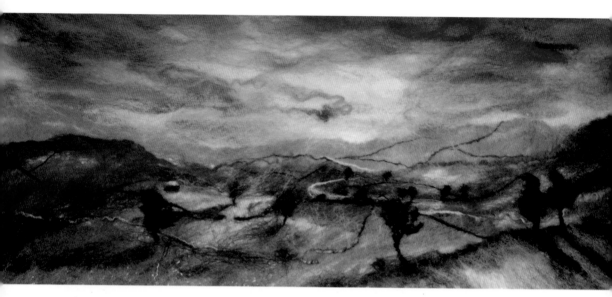

Wensleydale Sunset, 85 × 50cm (33 × 20in). The low setting sun creates long cast shadows from the trees and undulating hills.

the different tones of an object and the object's surroundings need to be considered when rendering a shadow. But generally the shadow of an object is the dark, less intense tone of its colour, and cast shadows are the darker, less intense tones of the colour that they fall upon.

The cast shadow can become more complicated if it crosses an area of several colours, because then it needs to take on the darker tone of each colour it falls upon. Where a cast shadow falls upon uneven land or objects, take care that it follows the contours. Also be aware of the

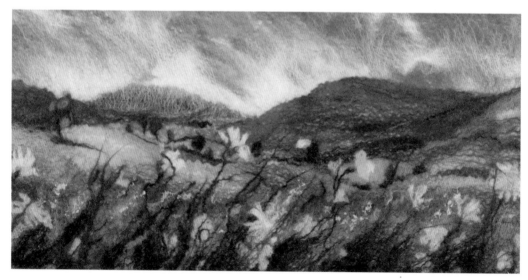

Dales Meadow, 75 × 50cm (29.5 × 20in). Light fluffy clouds help to create the light and gentle atmosphere associated with a summer's day.

change in tone of shadows within shadows, and the points at which the darkest tones within a shadow are present. Take note that any brightly coloured or lit object adjacent to the cast shadow might reflect some of its colour into the shadow; also light itself can be reflected, causing parts of the shadow to be quite light.

Light and shadow are often instrumental in creating atmosphere. The artist's mood and emotions are conveyed to the viewer through atmosphere. Often simply changing the light can have a profound effect, and can turn a mundane scene into something really special that demands the attention of the viewer. By exaggerating the atmosphere, the mood of the whole picture can be changed. The use of plenty of fresh bright light can make a scene appear jolly and uplifting, whereas a scene with strong directional light and long shadows can often create a very evocative picture.

Landscape artists frequently rely on the sky to convey the atmosphere in a scene; this is due to the fact that the sky determines the quality of light upon the entire scene. The artist is therefore constantly stimulated by the ever-changing weather,

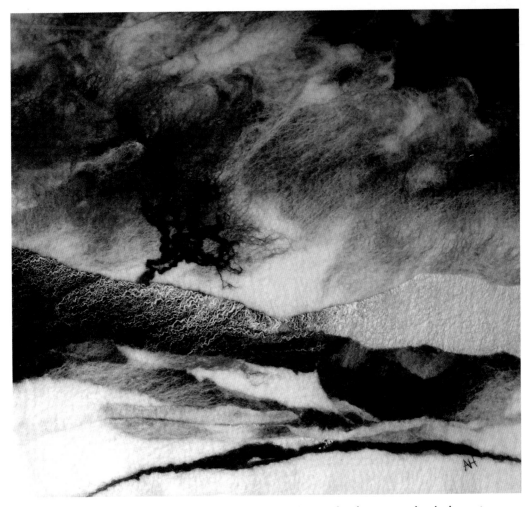

Solitary Hawthorn, 60 × 60cm (35.5 × 35.5in). The dark, heavy clouds suggest that inclement weather approaches.

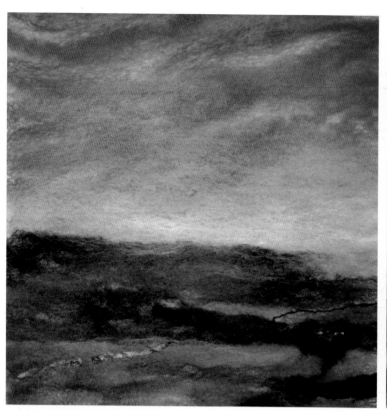
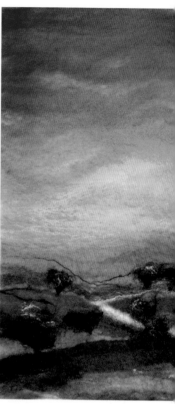

and the subsequent ever-changing colours of the landscape. The landscape artist is very aware of how the sky influences the mood of a picture. For example a sunset with horizontal cloud formations and warm underlying colours helps to promote a sense of calm in the viewer, whereas a landscape partly shrouded in mist can create a very ethereal atmosphere.

Light also plays its part in creating distance, as the sky is normally lighter at the horizon becoming darker as it meets the viewer. Cloud formations help to give a feeling of movement, and add to the atmospheric quality of the picture. When creating a sky using wool tops, a good method of blending the colour is by carding, as it gives a smooth mix with gradation of tone. The light and dark tones can be varied to give the appearance of a light, fluffy cloud, or one that is dark and heavy with rain. Wool can also be used very thinly to suggest wispy clouds.

Synthetic or Natural Dyed Tops

Synthetic dyes produce bright and vivid colours as well as rich dark ones, and there are many suppliers of wool tops offering extensive colour ranges of commercially dyed wool tops, silks and mixed fibres. The feltmaker now has a wealth of exciting materials to indulge their craft. As an artist I am particularly interested in the variety of dyed wool tops. The wide range of colours enables me, along with my own colour blending, to create any colour I want.

I am often asked if I dye my own wool. The simple answer to this is, no. Undoubtedly there is something aesthetically pleasing about dying one's own wool, but it is time-consuming and I prefer to spend my time

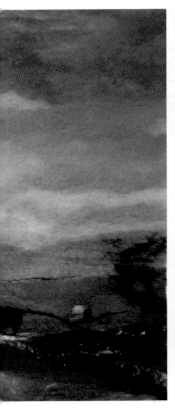
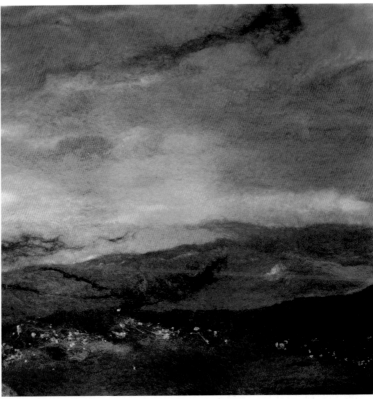

creating pictures. Also, in my experience the ease with which the commercially dyed wool pulls from the top is superior to that of hand-dyed wool. Hand-dyed tops have a tendency to feel somewhat matted together, perhaps because the wool top has begun to felt when in the dye bath. The ease with which the wool fibres separate from the top is very important because it allows the wool to be pulled from the top effortlessly, and worked in a very spontaneous, relaxed way, which contributes greatly to the overall nature of the piece.

The quality of the commercially dyed top is now such that the user can be confident in its resistance to bleeding and fading, and also the colour is consistent throughout the length of the top. This last point can, however, sometimes be a disadvantage to the felt artist, because if the top is uniform, then very

ABOVE: *Big Sky*, triptych 150 × 50cm (59 × 20in). The subtle tones of naturally dyed wool tops blend together harmoniously to capture perfectly a winter sunrise.

gentle gradation and subtlety of tone is hard to achieve. I have found that in depicting a winter sunrise, for example, naturally dyed wool tops capture the natural beauty and translucent quality of such a sky more sympathetically. So although the naturally dyed tops are not always easy to work with, the results far outweigh the slight loss of spontaneity – and certainly the feeling of affinity between using wool dyed with natural dyestuffs to create images of nature is appealing.

NATURAL DYED TOPS

by Shirley Simpson, specialist natural dyer

Undoubtedly it is much easier **not** to dye one's textile fibres, and all those who spin, knit, felt and weave are able to buy ready-dyed fibres in great variety. Proportionately, the cost of such ready-to-use fibres is not great, especially when one considers the stages through which a fleece must pass before it is presented to the user as a supple, coloured woollen top ready for immediate use. Most of the beautifully coloured tops available for felting will have been dyed commercially after the fleece has been scoured. Synthetic acid dyes are the most likely dyestuffs to have been used to colour the fleeces, and these are available in a huge range of colours. It is also possible to mix endless variations both in the commercial dye houses and in one's own dyeing space at home. Look critically at a length of commercially dyed tops. The dyed colour will be even and level – open up the fibres and the dyeing will still be as consistent. In large part this will be the result of dyed wool passing through successive carding machines that have the ability to minimize or even negate any irregularities in both the fibre and the dyeing.

Naturally dyed wool tops.

Textile enthusiasts are likely to have collected a few hand-dyed, handmade treasures, perhaps from holidays abroad, and it is quite possible that these textiles will be hand-dyed with natural dyestuffs. The differences between the fibres dyed with synthetic dyes and the naturally dyed top will be very apparent. Harald Böhme, in his splendid book on natural dyeing (*Koekboya*), refers to the monotony of synthetic dyeing, where reproducable colour tones are typically a sign of quality dyeing. Natural dyes do not always exhibit this regularity and evenness of tone. The word 'Abrash' is used to indicate the gentle graduation and subtlety of natural dyes throughout a textile.

There are subtle and harmonious colour nuances which are apparent on fibre when dyestuffs prepared from natural substances are used. This is due in large part to the composition of the dyes. The dyer will be largely concerned with the production of a naturally coloured solution to apply to a mordanted fibre, rather than feeling the need to offer a blanket coverage, which can mask imperfections and will even out the finished dyed effect.

Recently, dyers have the opportunity to sample natural dye extracts, presented most frequently in powdered form. Running through the names of these dyes is comparable to flicking through the pages of a book on natural dyeing: chlorophyll, cochineal, cutch, indigo, lac, logwood purple, madder and quebracho red – these are all available as powdered extracts. Fustic and osage orange are available as liquids, while weld, a truly luminous yellow green, is in powder form. The origins of these extracts are world-wide. They are produced from raw dyestuff materials: barks, woods, leaves, flowers, roots and insects. The colouring pigment is extracted with water; this is distilled and evaporated to form an extremely concentrated extract.

The extracts are easy to use and pleasant to handle. They may be weighed and used as a percentage of the weight of fibre to be dyed, or, most usually, measured with a teaspoon or

tablespoon. It is worthwhile investing in a set of measuring spoons: one eighth, one quarter and one half teaspoon, one teaspoon and one tablespoon. Frequently half to one teaspoon is sufficient to dye 100g (3.5oz) of mordanted fibre. The extracts are thoroughly dissolved in a little warm water (madder, cutch and quebracho red prefer cold water), which is then added to warm water in the dye bath. This is stirred well. The mordanted, wetted fibre is then added to the dye bath, which is slowly heated to 85°–90°C (185°–195°F). The temperature is maintained for a further 35–40 minutes. This is a brief outline of immersion dyeing, which may be used for fleece, yarns and fabrics. Tops require a different treatment, and recipes follow.

There are three distinct stages in the dyeing of a woollen top with natural dye extracts: wetting out, mordanting and dyeing. At every stage, handle the top very gently. When the dyeing is completed the top should still be a loose and flexible fibre rope, ready for feltmaking or spinning.

When working with these extracts, it is all too easy to forget that they are dyes, and as such must be kept quite separate from daily life in terms of a simple health and safety routine. Please be aware that natural dyeing involves the use of substances that could cause ill effects if swallowed or inhaled. Therefore it is sensible to store dyes and dyeing equipment in a secure cupboard out of the reach of children. Equipment used for dyeing should be kept solely for dyeing and marked thus, with enamel paint or waterproof pen. Keep an old shirt or apron to wear when dyeing, and make use of disposable plastic gloves and a dust mask when handling the dye powders.

Recipe for 100g of Tops

Some form of heatproof container measuring approximately 40 × 30cm (16 × 12in) will be needed to be used as a dye bath for all three processes. It is not too difficult to find discarded metal roast-ing tins at household auctions and car boot sales, and discount warehouses sell new equipment cheaply. Purchase the most robust one you can afford. A thermometer is essential and a great timesaver; these may be purchased from shops selling winemaking equipment. Choose whichever scale you are familiar with, Centigrade (0°–110°C) or Fahrenheit (32°–220°F).

Wetting Out

Allow a minimum of two to three hours for 100g (3.5oz) of tops. Arrange the top in a zigzag fashion in a clean container. Put three to four drops of washing-up liquid in a 2ltr (3½ pint) measuring jug. Fill with hand-hot water and stir. Starting at one corner of the container, pour the solution on to the top, gently pushing the fibre under the water. You may need to add another litre of water to ensure the length is just covered with water.

Mordanting

Mordanting is an essential fixing procedure for most natural dyes and extracts. Potassium aluminium sulphate (alum) is a recommended mordant: it is considered to be non-toxic, plus it is economical in use. The residue from mordanting may be diluted with cold water and disposed of down the lavatory or on a non-productive area of the garden. Alum can usually be obtained from small independent chemists, and from some pharmacies in large supermarkets.

To Prepare Mordant

• For 100g (3.5oz) tops, thoroughly dissolve two slightly rounded teaspoons of alum in a measuring jug or old cup using a small amount of very hot water. Add this to 2ltr (3½ pints) of warm water. Stir well.

• Remove the tops carefully from the container, and discard the water. Squeeze out any surplus water.

• Rinse once in fresh, warm water, carefully supporting the weight of the top. Return to the container, again in a zigzag fashion.

NATURAL DYED TOPS *(Cont'd)*

- Pour over the mordant, gently pressing the fibre into the solution. Add a little more water to ensure the top is just covered.
- Cover the tin loosely with aluminium foil.
- Heat to 85°–90°C (185°–195°F) over 45min. Check the temperature with a thermometer periodically. Hold at this temperature for a further 45min.
- Switch off the heat and allow the mordant bath to cool down completely – overnight is preferable.
- Rinse the top in warm water, handling gently at all times. Wrap it loosely in an old towel while preparing the dye bath.
- Note it is useful to have a supply of pre-mordanted fibre (fleece, yarn, tops and fabric) for one mordant in multiples of 100g. Use each mordant bath twice; for the second bath add half the original quantity of dissolved alum to the original liquor, topping up with water as required.
- Damp, mordanted fibre can be stored in tightly fastened and labelled plastic bags in an old refrigerator – I have a very battered, but still functioning refrigerator bought for £15 via an advertisement in our local paper. When you want to use some of this mordanted fibre, wet it for about one hour in warm water until it is completely saturated and ready for use.

Dyeing Top
- Arrange in container as previously described.
- Select extract. Put 1–2 level teaspoons into a small jug or cup. Blend with warm water using a tiny balloon whisk to completely dissolve the extract. These may be bought very cheaply at discount shops.
- Put 2ltr (3½ pints) of warm water in a measuring jug. Add the blended extract. Stir thoroughly.

- Pour the dye liquor over the mordanted fibre in the container. If necessary, add sufficient extra water so that the wool is barely covered. Allow the container to stand for at least one hour; this enables the dye solution to soak into the fibre.
- Cover the container with foil – loosely. Allow for a 'steam vent' in one corner.
- Heat slowly for 30–40min, to a steady 85°–88°C (185°–190°F). Hold at this temperature for a further 40min.
- Turn off the heat. Allow the dye bath to cool down completely, preferably overnight. If you are very patient and can wait a further two days, the take-up of dye into the tops will be improved.
- Squeeze the top to remove the excess liquid (do not twist or wring).
- Rinse very carefully in two or three changes of tepid water, until no dye residue is visible.
- Place an old towel on a working surface. Arrange the tops on the towel, gently straightening the fibres. Roll up tightly in the towel. Leave for 30min.
- Hang to dry (not in direct sunlight), gently aligning the fibres periodically.

Have you tried dyeing tops prepared from a coloured sheep? British spinners have a generous selection of coloured fleeces to use. The beauties of these exciting dye extracts are further enhanced when they are used on coloured fleeces.

A fully illustrated natural dye instruction book can be bought alongside the products. This is written by Michele Wipplinger, the experienced and very knowledgeable American dyer who founded Earthues. The book sources each dye extract and gives specific recipes and appropriate quantities for light, medium and dark shades.

Applying Colour
to your Picture

Before adding colour to your picture, it is advisable to have drawn out with some wool, a simple sketch setting out the basic composition of the picture. Think about the colours you want to use and try to visualize them in your picture. Do not be apprehensive of moving things around, because balancing colour as well as objects is a very important part of the composition. Proceed with your picture in the following stages.

Block in areas of colour to give a sense of colour balance in the picture, but do not get drawn into adding detail at this point, as this step is all about organizing the overall composition of the piece. You may find it helpful in balancing the colours to work on paper sketches with crayons or paint. But remember any coloured wool placed on your picture at this point can easily be removed, so do not shy away from a little trial and error with the wool. Any rejected colour will no doubt be used later, in this or another project. Ultimately you need to be happy with your decision, so do not rush things. Spray the picture with some of the soap solution when you are happy with the colour balance.

Next think about the light in the picture. Sky is often the source of light and colours are usually lighter on the horizon, so that is a good starting point. From there, work your way down the picture, identifying the light areas. Think about the direction of the light and where shadows might fall. The light areas can be created by using thin layers of light-coloured wool, to capitalize on the white of the first two layers in the base. Alternatively white wool can be added to the colour and blended. It helps to squint your eyes when you look at the picture; this eliminates detail and colour so you can more easily identify light tones.

The same squinting technique can also be used to identify the darkest tones. Pick out the very darkest areas: these might be dark-coloured objects or shadow areas. Put them in roughly, using a dark mix of the object's colour or the surroundings that the shadow falls upon. This may appear quite black, but be very careful, as things are rarely solid black. You can always go back later and strengthen the darks if necessary.

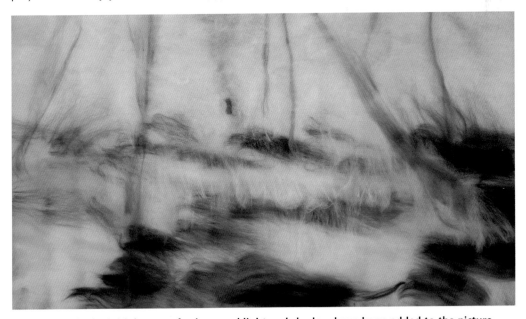

Hardraw Beck: the initial areas of colour, and light and shadow have been added to the picture.

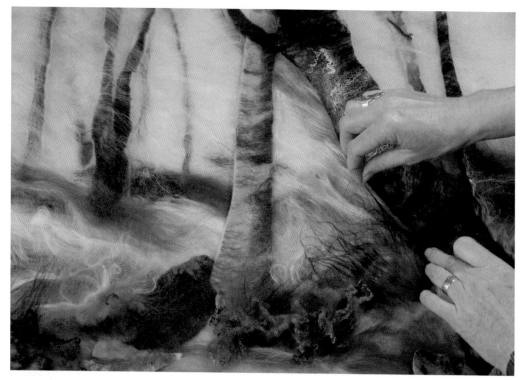

Hardraw Beck: the picture is now being worked into with coloured wool tops, pre-felt and other fibres.

Give the picture a very light spray with the soapy water solution. If you are leaning over the picture, place a piece of bubble wrap over the bottom third, to prevent any disturbance of your work; this can be carefully peeled back later when you need to work on that area.

With the light and dark tones identified, you then need to blend these tones together, mixing colours to create several tones and placing them on the picture. Handle the wool as if you were creating a three-dimensional object – and indeed there is an element of sculpture in the physicality of working with wool in such a way. Select the coloured wools and mix the colours using whichever blending technique you think most suitable for the desired effect. Spray lightly with soapy water as needed. This stage may take hours or days depending on the complexity of the picture and how skilled you are at colour mixing. Getting to grips with colour theory and

the techniques of mixing coloured fibres can take time, so don't rush, and enjoy the experience of working with such wonderful fibres.

Before adding any detail, take time out from the picture. When you return, look at it with a critical eye: consider whether the dark areas are dark enough, and the relationship between the darks and the light: is there sufficient contrast to make the focal point stand out? Have you got the intensity of the colours right? If you need to make adjustments, do so now before starting to add details.

The final stage in the creative process is to add detail and extra texture if desired (see Chapter 6). A detail can be a white spot of wool or pre-felt to create a highlight, the stamens of a flower, or the striking features of a face. Creating detail usually involves a degree of intricate and time-consuming work: it is therefore advisable to leave this towards the end of your project when

THE FELTING NEEDLE

The best way to add small but important detail after the picture has been felted is with a felting needle. This is done by pushing strands of wool into the felt with the needle, which has several barbs along its length to catch the wool fibres and secure them into the felt. It is advisable to place a thick piece of polystyrene or other suitable material behind the felt to protect your hand from being stabbed by the needle.

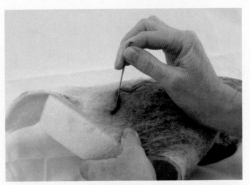

Using the felting needle to add small details.

any alterations have been made, and there is less opportunity for careless movements to disturb the details. Also when working with wool, very small details can be consumed by the picture in the felting process. In such cases these tiny but crucial details are best added to the picture after it has been felted and dried. When you are happy with the picture and have added all details and textural effects, the felting process as described in Chapter 3 can begin.

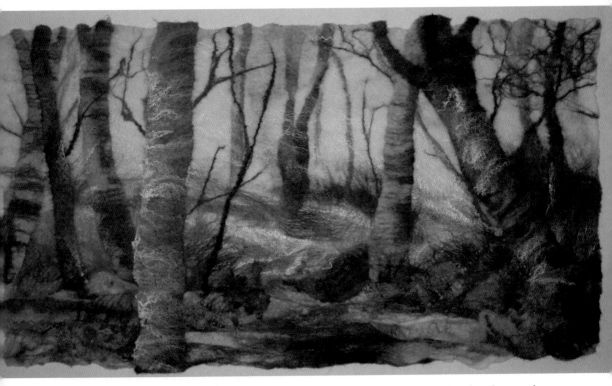

Hardraw Beck, 80 × 55cm (31 × 22in). **The picture is now finished; it has been dried and pressed, and is now ready for framing.**

ADDING
EXTRA TEXTURE

The very nature of drawing and painting with wool creates a picture rich in texture. By selectively adding extra texture a picture can be improved still further, for example by giving prominence to a focal point or in creating balance in a composition. Texture is therefore a very significant part of a felt picture, and to many textile enthusiasts it is its most interesting aspect.

With the ever-increasing popularity of felt-making, a desire for fibres that create interesting effects in the felt has also escalated. Most good retailers of wool tops will also sell fibres suitable for adding texture in the felt. The fibres associated with feltmaking are very wide ranging, and include those such as bamboo, soybean, banana, silk, cotton and synthetic fibres, in addition to the numerous wool types and interesting blends available. So extensive is the variety, this chapter will explore just a few of the most effective fibres for adding texture in a picture. All the fibres discussed need to be combined with good quality felting wool in order for them to lock into the felt.

Wool nepps: These tiny bits of felted wool are a by-product of the woollen industry. They are usually sold in small 100g (3.5oz) quantities, and are excellent for adding an interesting tex-

ture to a picture. They are particularly effective when used to suggest, for example, blossom on a thorn tree or a sprinkling of flowers in a meadow. The bits tend to stick together in clumps and therefore need thinning out before applying to your picture. They felt in well with the rest of the wool, and are well worth the space in your workbox.

Cotton nepps: These are very similar to the wool variety and again are very effective as an interesting texture. Use them thinly and well spaced, as they tend to migrate back to each other. This is because they don't lock into the wool as well as the wool variety; it is therefore wise to spread a thin veil of wool tops over the nepps to secure them into the felt when the picture is rolled. These nepps work well when added to some wool tops, and then carded to create a speckled blend.

OPPOSITE PAGE:
Detail from *A Place to Grow*.

RIGHT: **Cotton nepps.**

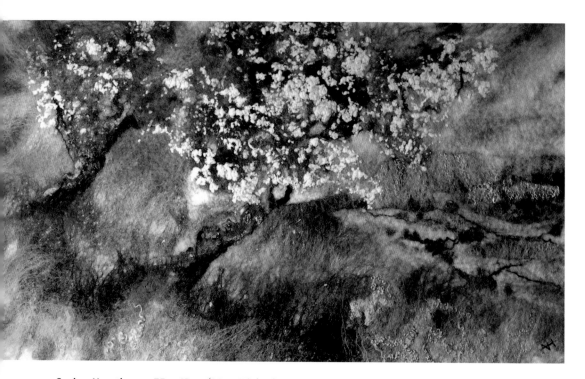

Spring Hawthorns, 75 × 45cm (30 × 18in). **The cotton nepps perfectly capture the trees laden in blossom.**

Throwster's waste: This is a by-product of the silk industry and is sold in bundles of fibres in various lengths. To use, the fibres are teased out into a very thin layer, then laid down on to the picture; the wool fibres then interlock with the throwster waste when felted. The fibres naturally crimp in the felting process, producing a crinkled effect in the finished picture; this, combined with their soft lustre, creates a very interesting texture.

Tussah silk: This is a wild silk produced by silkworms that live naturally in tropical forests. Their silk is gathered after the moth emerges, unlike cultivated silk. The natural fibre is irregular and golden in colour, but is available as white bleached fibre and in different colours. It can be bought as silk top, which makes it easy to work with, as the fibre can simply be pulled from the top and laid down on the wool, where it mingles with the wool fibres. It is quite lustrous and has a random wave in the fibre, providing interesting effects particularly when portraying water.

Mulberry silk top: This is a cultivated silk which is white in its raw state. It has a high lustre, which, when combined with wool, provides the felt with a fantastic shimmering effect. This is very useful in creating highlights in a picture. The silk fibres must be sufficiently open in order to mix with the wool fibres. The silk top is difficult to work with if your hands are rough, because the silk is so fine it will stick to your skin.

Nylon top: Nylon is a synthetic fibre that is easy to dye and is therefore available in many colours and combinations, such as multi-coloured rainbow-dyed tops. It is very shiny, and when mixed with thin strands of wool fibre gives a high sheen, so use it sparingly. Because it is available in many colours, it can be useful in creating

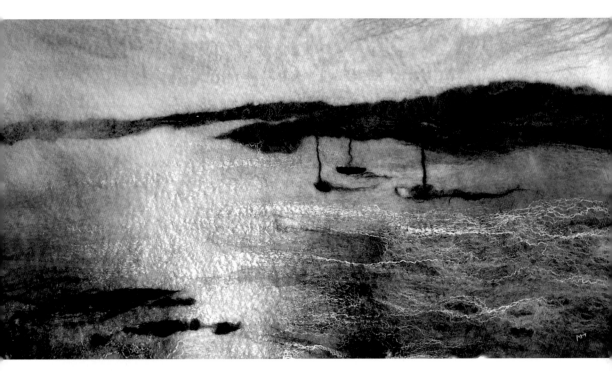

ABOVE: *Seascape*, 40 × 25cm (16 × 10in). The shimmering water effect was achieved by laying down a fine layer of mulberry silk with the Merino wool tops.

Mulberry silk.

Nylon is effective when mixed with wool tops to give the shimmering effect often associated with light on water.

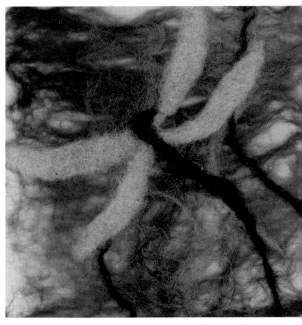

Dragonfly.

shimmering effects in numerous situations. Its disadvantage is that if it is overused in certain circumstances, it can make a natural scene look very artificial and out of character.

Wensleydale locks.

Blended tops: Many suppliers now offer tops of numerous blends, such as merino with tussah silk or merino with nylon. These can be quite time-saving as the blending is done for you.

Wensleydale locks: The curly Wensleydale fleece is a favourite with those who make felt figures, as the long, lustrous locks are perfect for creating a good head of hair; of course this could equally apply to a portrait picture. They are available in their natural colour and in many dyed colours, which lend themselves to giving excellent textural quality, for example to a landscape or a close-up study of mosses and lichens. Wensleydale wool is quite a good felting wool, but in order for the locks to be secured into the picture, the fibres should be sufficiently teased out to allow the Wensleydale and the merino fibres to mingle and become felted together. The end portion of the locks should be left intact; these will then remain remote from the body of the work and create pleasing curls.

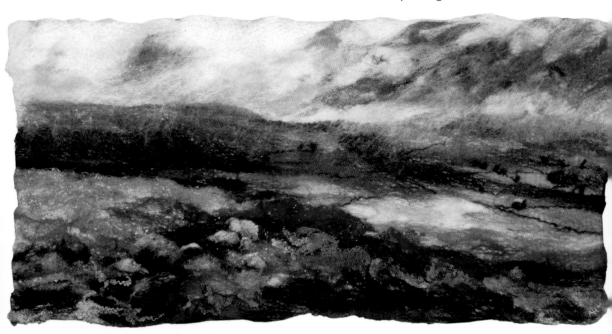

High Places, 90 × 50cm (35 × 20in). The curly locks of the Wensleydale fleece are perfect for adding interesting texture; they are particularly effective in capturing the heather in the foreground of this picture.

ABOVE: **Blue-faced Leicester locks.**

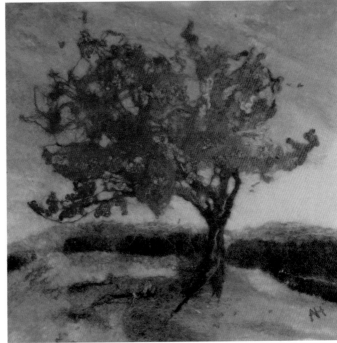

RIGHT:
Autumn Hawthorn,
45 × 45cm (18 × 18in). The
hawthorn tree in autumn has
brilliant colours and textures,
and the dyed Blue-faced
Leicester locks are ideal for
portraying the leaves
and their vivid colours.

Blue-faced Leicester locks: These locks are long but not as lustrous as the Wensleydale and have a smaller curl. The Blue-faced Leicester locks felt into the merino base rather better then the Wensleydale, but it is still wise to treat them as you would the Wensleydale. Both curly locks are available in varied colours, and are usually sold in small quantities, such as 100g (3.5oz) bags.

Cut and reveal: Interesting textures can be achieved after the picture has been felted and dried by cutting through the top layer of wool with sharp scissors to reveal different coloured layers. However, take great care not to cut right through the picture.

Bits and pieces: Textile enthusiasts will no doubt have collected many treasured bits and pieces over the years, and stashed them away to be used on that perfect project. Sadly that is where many stay, only to be looked at and handled longingly on brief occasions, then put back in the drawer. This is the time to get them out again and experiment with them. Many fibres and materials can be added to a picture to give texture, providing they are used in conjunction with merino wool to ensure that they all lock together in the felt. Bits of yarn can be useful for making lines, and scraps of lightweight open-weave fabrics such as silk georgette and cotton muslin can each create their own indi-vidual effect. However, be mindful of the fact that wool shrinks in the felting process, and this can cause any non-shrink materials to wrinkle and crinkle up, resulting in what may be a very undesirable effect in a picture. Experiment with different fibres before incorporating them into a major project.

Many embroiderers make felt to be used as a base for their embroidery. Felt is indeed a beautiful base on which to work. Extra texture is often applied through hand or machine embroidery, gilding and beadwork. My approach to felt picture-making is very different, in that I use the same basic principles and follow the same format as a painter; therefore once my picture is felted I consider it finished, unlike the embroiderer whose creative work is often just beginning. In fact my work has encouraged many embroiderers to be more imaginative in the design of their felt base, and has helped them achieve greater depth in their work by creating a more interesting base upon which to work.

Stitches can also certainly play an important part in enhancing a felt picture: for example, a row of carefully positioned stitches can lead the viewer into the picture, and a well selected embroidery stitch can greatly enhance a focal point. Alas, I am no embroiderer and therefore only use the previously discussed methods when adding extra texture to my work.

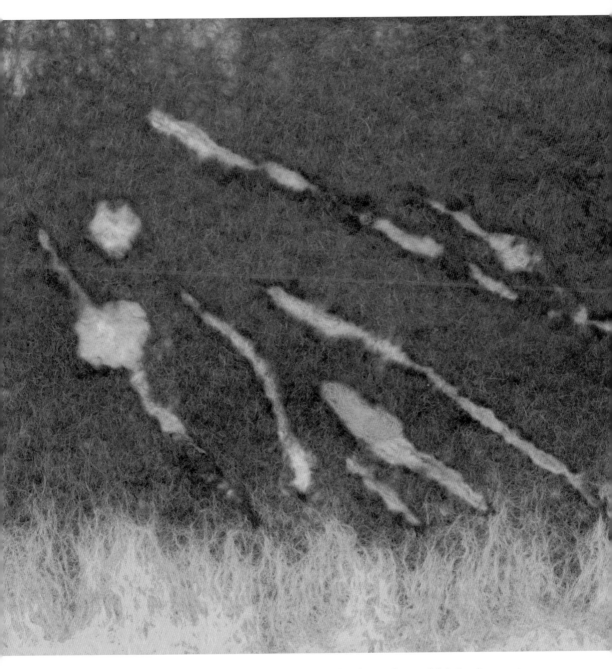

This example illustrates the technique of 'cut and reveal'. The top layer of felt has been cut away to reveal the brighter, more vivid colours underneath.

PRESENTATION AND FRAMING

The software related to digital cameras has given the artist the great advantage of being able to record, edit and catalogue images of their own work, a facility which has proved to be invaluable for the professional artist. Together with the huge advantages of email, this has made all kinds of art accessible internationally. The fact that an artist can email images of new works to a prospective client on the other side of the world almost instantly has opened up a worldwide market; in particular for artists who live in isolated rural areas, the internet has made it possible to network globally.

For those intending to present themselves as a professional artist, it is very important to have a good website, and it is worth enlisting the services of a professional website creator. Try to find someone with an eye for artistic design and not just a talent for producing slick commercial sites, because it is also important that the customer not only finds the site easy to follow, but that they get a sense of what your work is all about. After all, most people are buying into your concepts, as well as your pictures. Also make sure that the photographic quality of the pictures displayed on the site is good: bad photographs will not sell anyone's work.

Always present your work in a professional manner, whether it is on a website or at a gallery. Try to be organized: this can be difficult for artists and craftspeople, as their nature is often to be more concerned with the creative aspects of life rather than business matters – but curators and customers alike will expect a degree of professionalism. This also applies to the framing of your work.

Many textile enthusiasts do not like felt to be glazed because they feel unable to fully appreciate the textures when it is behind glass. This view is understandable, but I still choose to have most of my work framed and glazed, because I feel the benefits of doing so far outweigh the partial loss of textural admiration. In my experience, buyers appreciate that the felt is framed and glazed for practical reasons. The fact that it is presented as a painting detaches it from being a piece of hand-made fabric that might just as easily be made into an item of soft furnishing.

Sadly in most cases there is a huge financial bias towards what is perceived to be fine art and what is perceived to be craft, regardless of the talent and time spent on creating the item. My felt pictures to some may never be considered fine art and may therefore never realize the value of an oil painting, but the fact that each is presented as a picture in a frame lifts its value and allows it to command a higher price than if it were a cushion. Therefore consider carefully the question, to frame or not to frame?

I give a lot of thought to the framing of each individual felt picture, and with the help of my framer, I always try to come up with a frame that gives sufficient protection to the felt and at the same time is sympathetic to the subject matter.

OPPOSITE PAGE:
Dragonflies.

FRAMING FELT PICTURES

by Bill Oakey, GCF

All forms of art are subject to fashion, and along with other decorative trends, styles of framing gradually change. Frames are simpler than they were just a few years ago, and mounts are bigger and plainer; but there are some constants. The very nature of felt is complex in that there are layers, textures, fly-away edges and strands of subtle colours; therefore the presentation should be simple in order to draw attention to the felt and not the frame.

Amateur feltmakers often know where their work will be hung and can ensure that the framing fits in, but professionals will have different criteria. They will need to choose a look that will appeal to most people, and they often have a 'corporate image' so that their work is recognized immediately and will hang as a unit at an exhibition.

Frames and mountboards for paintings should be sympathetic to the medium, the subject and the style, but felts are always soft, organic and indistinct. The medium is so often the subject, and this can limit the choice of a moulding to natural materials and the mount to pastel colours. The high-risk strategy is to do exactly the opposite and choose a hard, bright style.

It is preferable to glaze feltwork, because this protects it from dust, insects and other damage, but there should always be a gap between the

The positioning of the felt in the mount and the frame. The mount is slightly raised and does not touch the edges of the felt.

felt and the glass: this will maintain the felt's spongy thickness and the uneven depth of the layers without crushing it.

A mount around the felt is not always needed, but can raise the status of a piece of fabric into a work of art. A mount also makes the work bigger, which can enhance a simple frame. Note that if a mount is cut with the same dimensions all around, the bottom appears smaller; to avoid this optical illusion mounts are usually slightly bigger at the bottom.

If using a mount the edges of the felt should not be covered, so ensure that the window is wider than the image: the crisp edge of the mount will accentuate the unruly edges of the felt. This effect can be exaggerated by floating the mount above the felt by 5mm, casting a slight shadow. This shadow box has the added benefit of separating the glass from the fabric.

Mounts are now available in an almost infinite variety of colours and textures, and can be decorated and embossed, double or triple, with inlays or hand-finished, very thick, with a small wooden slip, or even round and oval. But beware of drawing attention to the mount rather than the feltwork.

Lighting is important for all artwork, but top lighting can emphasize a felt's irregular depth and texture. It will also increase the drama of a very thick mount or a shadow mount.

All artwork will damage in sunlight, and whilst semi-lightfast inks are now used on prints, wool is particularly sensitive, so feltwork should be kept out of direct sunlight and consideration given to using glass with an ultraviolet filter.

Good work that is poorly presented will be seen as undeserving, and you will be judged by the total work and not just the felt. Potential buyers will certainly be put off by work that needs reframing properly. There is little point in spending time designing and making a felt and not giving the same thought to its presentation.

Choosing a Frame and Glazing

The frame must be right for the picture, and this includes not just its look but also the way it protects the work, so the framer will need to know what standard of framing is wanted. The artist, not the framer, will be judged by an unsuitable or poorly made frame.

First consider the future of the work. If it is to be preserved to the very best standard for generations to come, the framing will need to be of museum standard: this will ensure that all materials that touch the work are acid free. It will mean mountboard that is made from cotton, not wood pulp, and adhesives that are neutral and reversible. Coloured mountboard will be light fast, and glass will have a UV filter. On the other hand, if the work is of no commercial or sentimental value then only temporary framing is needed, and a minimum standard is quite acceptable. What is really needed is generally somewhere in between these standards. Every level will give a sound, well designed frame, but the level of framing chosen will be reflected in the price.

Mountboard

Most mountboard was made from wood pulp, so contained acidic sap, which eventually turned the edges brown and marked the artwork where it touched it. Modern white-core mountboards reduce brown edges and minimize the transference of acid. Boards made from wood pulp can have the acid buffered to protect work for longer, and are often referred to as conservation mountboard. Only cotton board (sometimes called rag) has no damaging acid. The minimum level for original work is usually conservation board.

FRAMING FELT PICTURES *(Cont'd)*

Glass

Recent developments in glass technology have resulted in a confusing range.

2mm float glass is used in the vast majority of framing: it is excellent and very good value, but it can reflect and has a slightly green cast.

Float glass, when etched with acid, is commonly called non-reflective glass: it reduces reflections very effectively but can give a rather grey look, especially when it is lifted away from the artwork with a double mount. Float glass can also be made without the iron impurities that cause the green cast, so although it still gives reflections, it is sparklingly clear. This is called water-white glass.

Clear acrylic sheet has no green cast, and is very light and shatterproof.

All these types of glass can now have a UV filter to protect work from fading and becoming brittle. A recent improvement is a low-reflective glass which is coated on both sides rather than etched. The combination of low-reflective, water-white glass is the clearest glass available and is all but invisible. The best quality glass is water white and low reflective with a UV filter; it is often called museum glass.

The quality of glass is reflected in the price, and although prices are bound to fall as specialist glass becomes more popular, the top of the range can be an astonishing fifteen times as much as float glass – but it is wonderful, and glass accounts for only a small percentage of the price of a frame.

Backboard

As long as the backboard does not touch the felt, then MDF is quite acceptable. It is usual to fix the felt to a mountboard and stick this to the backboard. Foam-core board is increasingly popular. It is very light, rigid, and will not damage artwork; however, it is more expensive.

Frame Material

Traditionally frames have been made from lengths of wood, but they are now also made from moulded wood pulp or polystyrene, and it can be difficult to tell the difference when they are hanging on a wall.

Plain wood has a natural beauty which can be enhanced with stains or lime wax, complementing the natural look of feltwork. Traditional gilding is less popular now, even though very good decorative finishes are available.

Moulded wood-pulp frames come in various shapes, widths and depths, and are usually factory finished with paint or stain. There is an almost infinite choice, and they represent the best value in mouldings. Increasingly the wood used in framing now comes from sustainable sources.

Recent developments have resulted in very presentable extruded foam mouldings, which are extremely light and relatively cheap.

Aluminium frames come in very bright finishes or brushed, and in a wide choice of startling colours. Because they are very rigid they can be almost impossibly slim. The uneven, soft look of felt can look arresting when framed in hard, slick aluminium.

Round and oval frames are available in a limited number of styles. Frames with other than four sides can be made to order, and always attract attention.

The minimalist way to frame a felt is with a sheet of clear acrylic glass, lifted off the mounted felt with chrome posts through each corner of the acrylic to the backboard.

Hanging Artwork

The most popular way to hang artwork is from nylon cord stretched between two D-rings fitted to the back of the frame. The rings must be screwed to the frame and not to the backboard. Screw-rings with a loose ring through an eye, are suitable for light frames. Nylon cord will not break, but it can stretch a little.

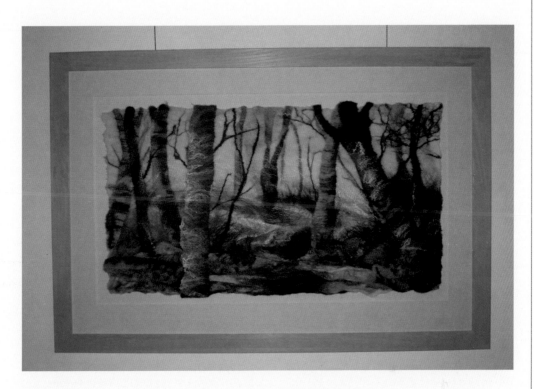

Hardraw Beck, **80 × 55cm (31 × 22in). The finished picture framed and hung in the gallery.**

Exhibition organizers usually ask for mirror-plate fixings which are screwed flat to the back of the frame and stick out of the sides. The frame is screwed to the wall from the front. This also avoids the storage problem of rings scratching the front of a frame which is stacked behind it. If D-rings are used then frames should be stored face to face.

Fixing Felt to the Backboard

By its nature feltwork cannot simply be hung from its top corners like a painting, or glued flat to the backing board, or held down with a window mount. The beauty of the loose, free edges needs to be seen, and it cannot be flat-tened with pressure without losing the vary-ing depths and textures. Very delicate work is often transparent in places. Furthermore many fixatives and glues are heavily damaging and should be avoided as they will stain and be-come brittle over time. Attaching a felt to a backboard is therefore a matter of choosing the least worst method.

Starch glue is natural and clear, and will not damage the fabric, but will soak in and is there-fore not reversible. Clear silicone mastic is inert, colourless and remains flexible, and the felt sits on it without it soaking in, so in theory can be removed. It does, however, have a very strong smell so should not be applied in a closed room, although the smell disperses in a few hours.

FRAMING FELT PICTURES *(Cont'd)*

Whichever you choose it should be applied thinly and selectively, and kept away from the edges, allowing them to fly free.

Professional Framing

There are plenty of people who can frame your work, and many will do an excellent job – indeed an amateur framer can afford to spend much longer on each frame, and will not have overheads such as rent or VAT, so can be excellent value. But an amateur may have only a limited choice of frames, and may not be able to keep to deadlines. Nevertheless some framers move into framing as a sideline to painting, so they are usually knowledgeable about differing art mediums, and sensitive to the artist's needs.

So before leaving your work with a framer, ask friends and fellow artists about the one you have chosen. Framers don't advertise too much, and a professional relies on word of mouth: reputation is all important. Professionals will have examples of their work to show you, and may even make you a mock-up of an unusual design so that you can see exactly what you are getting. Look at the back of a frame: if it looks tidy and well finished you can be assured that what cannot be seen inside the frame will be as well executed. Make sure the framer's name and address is on the back.

Never leave your work with a framer without getting a written quote giving the price and a completion date; this also acts as a receipt for your work.

The framer also needs to know if you are working towards an exhibition date: it is essential to give him enough time. It is not professional on your part to leave everything to the last minute, and expect the framer to drop other, planned work to fit you in. A professional framer will have the confidence to refuse a job that cannot be finished on time – but never will!

Once you find a suitable framer, use their experience and ask their advice. They have seen it all before and will be up to date on recent innovations in design, materials and techniques, and will know what the art-buying public is looking for.

But do not be coerced by the framer into choosing something you don't like: the final choices are yours alone.

A professional will have a wide choice of mouldings and mountboards, and will provide catalogues with hundreds of others. They will have contacts in the business, visit trade fairs and receive trade publications, so will be in touch. Professional framers will give a personal service, but they will need to know your exact needs and can then also offer alternatives. If you need a special hand finish to the frame, or a mount with multiple windows – just ask.

The most important advantage is generally overlooked, and that is insurance. A professional will insure your work whilst it is in their workshop, and you should never leave work anywhere without knowing it is insured.

Many framers will be in a professional organization such as the Fine Art Trade Guild, which sets industry standards for framing products and for the way a frame is made. They also ensure their members are professional in their business practices. The FATG also promotes professional framing qualifications. Their 'Guild Commended Framer' scheme is a rigorous examination with written and practical sections in framing practice and business ethics, and is now recognized world wide. Framers with GCF after their name are the élite.

Conclusion

Feltmaking can seem magical in its simplicity, the soft wool transformed by way of a little moisture and friction into a material that is strong and hardwearing. The basic principles of this ancient craft have remained unchanged to this day. Contemporary feltmakers have built on these basic principles to create very exciting, diverse ranges of functional, decorative and pictorial felt.

The growing popularity of feltmaking over the last ten years has now resulted in feltmaking becoming a valuable part of primary education, due to the fact that it involves design and creativity along with science and technology. This is all good news as regards feltmaking becoming a more appreciated art form. However, felt is some way away from being regarded by the art world as an equal to oil painting – nevertheless traditional boundaries are being pushed, and artists are experimenting more with mixed media and textiles in particular.

This book has illustrated how the imaginative feltmaker might adapt drawing and painting skills to feltmaking. However, while guidance in the use of various techniques is a valuable resource, ultimately artists have to find a way of working that suits them, and learning through experimentation and play is a vital part of that process. Often the best discoveries are made through mistakes, and new concepts evolve through enthusiastic play. This process is fundamental in forming the artist's own individual style and understanding of their chosen medium.

This book has highlighted the use of felt as a drawing medium, and I hope given you the confidence to be more adventurous when creating felt pictures. Ultimately I hope it has made you more enthusiastic in your love of textiles, and provided you with the foundations on which to create your own style.

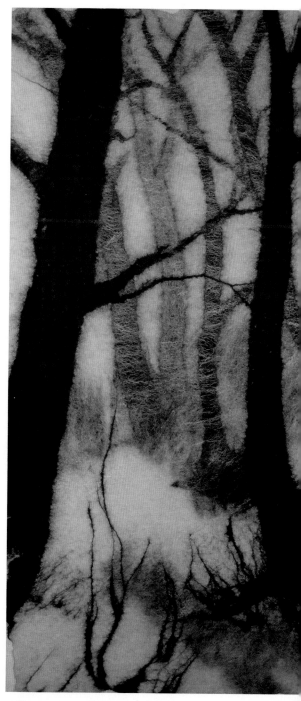

Tall Trees, 55 × 95cm (22 × 37in).

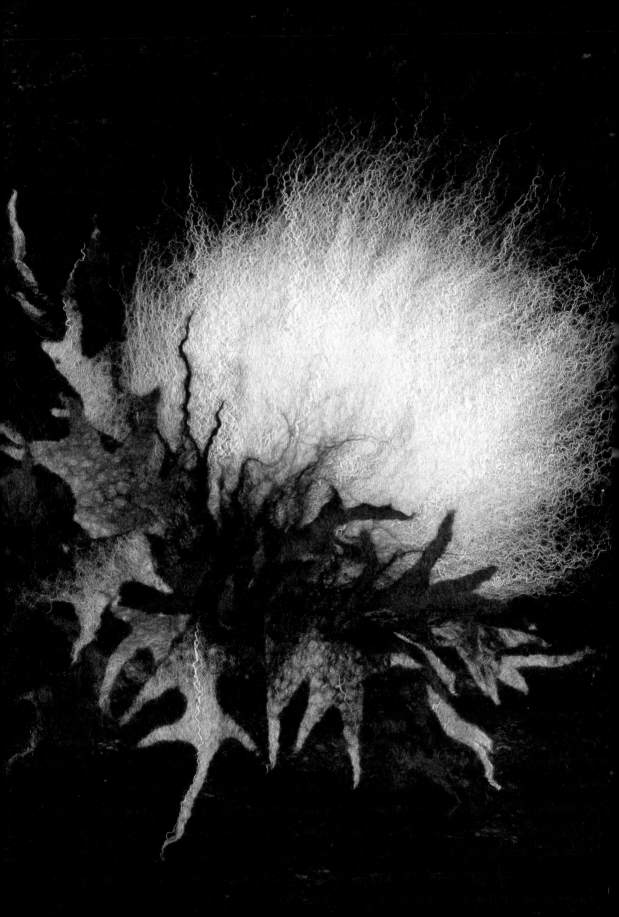

ACKNOWLEDGEMENTS

I would like to dedicate this book to my family, who have given me encouragement and support throughout my career, none no more so than my husband Stewart, who gives me endless support and help with everything I do.

My thanks also go to friends, and students for their help and encouragement over the years and whilst writing this book, particularly Delwyn Wilkinson, Sarah Lawrence and Dawn Stockbridge.

A special thank you must go to the people who have generously contributed to this book, Bill Oakey, Mavis Fawcett, Richard Ross and Shirley Simpson.

Last but not least I would like to thank the many visitors who call into my small gallery during the summer, their curiosity and enthusiasm for my work, is very uplifting and very much appreciated.

OPPOSITE PAGE:
Thistle, 60 × 60cm (24 × 24in).

GLOSSARY

Backboard The backing onto which a finished felt picture can be attached for the purposes of framing and display.

Carders Brush-like implements used to disentangle and straighten wool fibres, or to blend coloured fibres.

Cut and reveal A technique involving cutting through the top layer of a picture to reveal a different coloured layer beneath.

Fleece The shorn wool from a sheep.

Merino A breed of sheep mostly from Australia.

Mordant Substance used to fix dyes.

Mountboard The board from which picture mounts are cut, made from wood pulp or cotton board.

Nepps Tiny pieces of felted wool (or cotton) produced as a by-product of the woollen (or cotton) industry. Used for adding texture to a felt picture

Pre-felt Layers of fibre that have been sufficiently felted to make them just hold together. Also called 'half-felt'.

Roving see Wool tops.

Throwster's waste By-product of the silk industry, used to provide a crinkled effect in a felt picture.

Wool tops Wool that has been washed and carded, with the short fibres removed, and combed so the fibres lie in the same direction. Also known as 'roving'.

FURTHER READING

Ascher, Shirley, and Bateman, Jane *Beginner's Guide to Feltmaking* (Search Press)

Belgrave, Anne *How to Make Felt* (Search Press)

Burkett, M. E. *The Art of the Feltmaker* (Abbot Hall Art Gallery, Kendal)

Davis, Jane *Felting – the complete guide* (Krause Publications)

Docherty, Margaret, and Emerson, Jayne *Simply Felt – 20 easy and elegant designs in wool* (Interweave Press)

Garcia, Claire Watson *Drawing for the Absolute and Utter Beginner* (Watson Guptill)

Harris, Gillian *Complete Feltmaking* (Collins & Brown)

Houghton, Lizzie *Creative Felting* (Sterling Publishing Company)

Kaupelis, Robert *Learning to Draw: a creative approach* (Dover Publications)

McGavock, Deborah, and Lewis, Christine *Feltmaking* (The Crowood Press)

Peritts, Vivian *Wool Felting Workshop* (Sterling Publishing Company)

Smith, Sheila *Felt to Stitch: creative felting for textile artists* (Batsford)

Steel-Strickland, Robyn *Felt – irresistibly beautiful projects* (St Martins Press)

Tellier-Loumagne, Francoise *The Art of Felt – inspirational designs, textures and surfaces* (Thames and Hudson)

White, Christine *Uniquely Felt* (Storey Pub)

USEFUL ADDRESSES

Suppliers of Fibres and Equipment

Craftynotions Ltd
Unit 2
Jessop Way
Newark NG24 2ER
Tel. 01636 700862
Fax 01636 700862
Email: sales@craftynotions.com
www.craftynotions.com

Torbay Textiles
7, Hilton Drive
Preston
Paignton
Devon
TQ3 1JW
Tel. 01803 522673
Fax 01803 522673
Email sales@torbaytextiles.co.uk
www.torbaytextiles.co.uk
Mail order Merino, Wensleydale,
mulberry silk tops in an assortment
of colours and also undyed

World of Wool
Unit 8
The Old Railway Goods Yard
Scar Lane
Milnsbridge
Huddersfield
West Yorkshire HD3 4PE
Tel. +44 1484 649933
Fax +44 1484 649944
Email: info@worldofwool.co.uk
www.worldofwool.co.uk

Wingham Wool Work
70 Main Street
Wentworth
Rotherham
South Yorkshire S62 7TN
Tel. +44 (0)1226 742926
Fax +44 (0)1226 741166
Email: mail@winghamwoolwork.co.uk
www.winghamwoolwork.co.uk

North America

Acorn's Journey
449 Shane Street
Odessa
Ontario
K0H 2H0
Canada
Tel. 613-386-1869
Email: acornsjourney@cogeco.ca
A range of mixed reed wool for felting

Outback Fibers
Tel. 800-276-5015
Fax 440-575-6316
www.outbackfibers.com
info@outbackfibers.com
Outback Fibers specializes in supplying artists
with the finest felting fibres, including both
wool and felt, throughout North America.

Australia

Fibre Fusion
PO Box 67
Kew East, Melbourne
Victoria 3102
Tel. 3 9859 8081
Fax 3 9859 0107
www.fibrefusion.com.au
Email: askus@fibrefusion.com.au
Fibre Fusion produces and sells supplies
for felting, spinning, paper making
and other textile pursuits.

Norway

Hillesvåg Ullvarefabrikk AS
Leknesvegen 259
NO-5915 Hjelmås
Tel. 56 35 78 00
Fax 56 35 78 10
Email: hillesvaag@ull.no
www.ull.no
Suppliers of merino tops and other fibres for
feltmaking.

Suppliers of
Natural Dye Extracts

DT Craft and Design
7 Fonthill Grove
Sale
Cheshire
M33 4FR
Tel. 0161 718 3818
www.dtcrafts.co.uk
Dyes, yarns and equipment. Also workshops at
various venues across the north of England.

Pure Tinctoria
17 Moss Lane
Hulland Ward
Ashbourne
Derbyshire
DE6 3FB
Tel. 01335 370729
www.pure-tinctoria.com
Natural dyes, mordants, books and equipment.

Wild Colours
Unit I-135
The Custard Factory
Gibb Street
Birmingham
B9 4AA
Email: info@wildcolours.co.uk
www.wildcolours.co.uk
Natural dyes from plants.

US

Artisan Natural Dyeworks
5001, Indiana Ave
Nashville
TN 37209
Email: info@ecodyeit.com
www.ecodyeit.com
Natural plant- and earth-based dyes.

Earthues
5129 Ballard Ave NW
Seattle
WA 98107
Tel. 206 789 1065
Fax 206 783 9676
info@earthues.com
www.earthues.com
Fair trade natural dyes company, offering
starter dye kits, mordants, assists and books.
Also classes and workshops.

Griffin Dyeworks & Fiber Arts
174 W. Foothill Blvd #343
Monrovia
CA 91016
Tel. 626 359 3398
www.griffindyeworks.com
Dyes, pigments and felting equipment.

Table Rock Llamas Dyeworks
6520 Shoup Road
Black Forest
CO 80908
Tel. 719 495 7747
Email: tablerockllamas@msn.com
www.tablerockllamas.com
Natural dyes, mordants, yarn. Also classes.

Further Information

Feltmaking

For information on all aspects of felt and
feltmaking, including workshops and
subscription to Feltmatters, the quarterly
journal, contact the International Feltmakers
Association.
www.feltmakers.com

Wool

For information on British breeds of sheep and
their wool, contact the British Wool Marketing
Board.
www.britishwool.org.uk

For information on Australian wool, contact
AWI (Australian Wool Innovation).
www.wool.com

Projects for Children

Ideas for introducing children to making felt
pictures.
www.activityvillage.co.uk/making_felt_pictures.
htm

Artists Working in Felt

www.1-art-1.com
Mary-Clare Buckle produces colourful abstract
pictures in felt.

www.debbielucas.co.uk
Cumbria-based artist Debbie Lucas is involved
in community projects depicting landscapes,
plants and animals in felt.

www.devonwoollies.co.uk
Basic felt-making instructions, and some
interesting felt pictures by Peter Firby in the
gallery sections.

**For further information about the author's
own work, and to see where her work is
exhibited, visit the Focus on Felt Studio/
Gallery website.
www.focusonfelt.co.uk.**

INDEX

OTHER CRAFT TECHNIQUE BOOKS FROM CROWOOD

Abbott, Kathy *Bookbinding*

Brooks, Nick *Mouldmaking and Casting*

Brooks, Nick *Advanced Mouldmaking and Casting*

Burke, Ed *Glass Blowing*

Ellen, Alison *Hand Knitting*

Ellen, Alison *Knitting – colour, structure and design*

Fish, June *Designing and Printing Textiles*

Goodwin, Elaine *M. The Human Form in Mosaic*

Grenier, Fleur *Pewter – designs and techniques*

Parkinson, Peter *The Artist Blacksmith*

Perkins, Tom *The Art of Letter Carving in Stone*

Smith, Alan *Etching*

Taylor, Chris *Leatherwork – a practical guide*

Thaddeus, Martin, and Thaddeus, Ed *Welding*

Tregidgo, Jan *Torchon Lacemaking – a step-by-step guide*

Waller, Jane *Knitting Fashions of the 1940s*

Watkins-Baker Helga *Kiln Forming Glass*

Werge-Hartley, Jeanne *Enamelling on Precious Metals*